IMAGES
of America
WILLIAMSTON

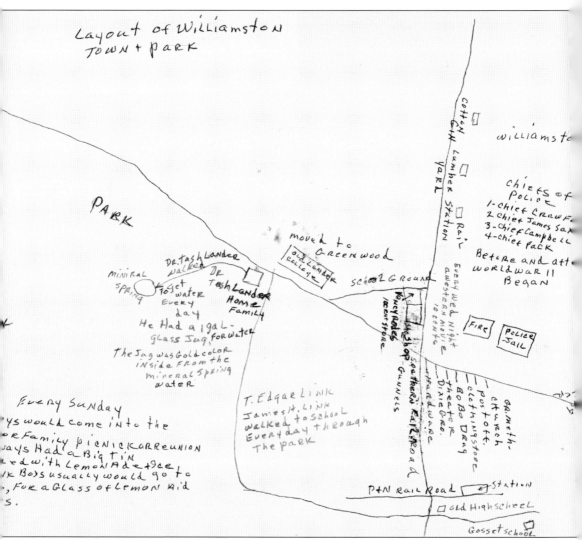

James Link graduated from Williamston High School in 1942. He grew up on a farm outside of the mill village and walked to elementary school through Mineral Spring Park in Williamston. He drew this map showing the town built around the park as he remembers it from his youth. (Courtesy of James Link.)

ON THE COVER: Williamston High School closed in 1953 when Palmetto High School opened off Hamilton Street. Jack Ellenburg, class of 1960, remembers Jack Gentle, pictured in the white box at the top. "He would let me go into the press box, as we called it," Jack said. "He would announce the players and direct band performances as they paraded on the field at half time. He was known for his clear, clean voice and the excitement in it. That fascinated the crowd." (Courtesy of Jane Harper Lawless.)

IMAGES of America
WILLIAMSTON

Susan Woody Martin

Copyright © 2016 by Susan Woody Martin
ISBN 978-1-4671-1484-4

Published by Arcadia Publishing
Charleston, South Carolina

Printed in the United States of America

Library of Congress Control Number: 2015938324

For all general information, please contact Arcadia Publishing:
Telephone 843-853-2070
Fax 843-853-0044
E-mail sales@arcadiapublishing.com
For customer service and orders:
Toll-Free 1-888-313-2665

Visit us on the Internet at www.arcadiapublishing.com

Paul Jennings Woody was an unpretentious man who realized the value of honesty, hard work, and empathy. He was a father who saw potential above disappointment. This book is dedicated to his memory and legacy.

CONTENTS

Acknowledgments		6
Introduction		7
1.	The Foundation and Education of Williamston	9
2.	Vision Brings Prosperity	29
3.	Business Draws Government	49
4.	Stories of Healing, Friendship, and Camaraderie	57
5.	Celebrations of Heritage	103

Acknowledgments

The contents of this book emerged from the stories told by several Williamston historians. Rich recollections of bygone days tell of the heritage of a town formed from a farmer's dream. Jack Ellenburg relives his youth through daily walks around town. Due to her aunt's memorabilia, Jane Tucker Addison's historical inventory is deliciously abundant. Julie Cole's heritage continues to mark the streets and buildings in town. Thomas Addison and his mother, Betty Looper Addison, enliven the memory of West Allen Williams through stories and pictures.

Jane Harper Lawless shares treasured photographs in telling her memories of an independent mother who captured Williamston history as a photographer with the *Anderson Independent* newspaper. Jane's uncle Mac Harris Jr. tells of former pharmacies, cafés, and hangouts. Connie Barnwell, with her thorough research and dedication to accuracy, paints a vivid tale of benevolence and inspiration. Jean Taylor catalogs past and present Williamston on the "I'm from Williamston" Facebook page. Sarah and John Dacus tell about deep roots reaching from Williamston to other parts of the world. T.E. Mattison chronicles the history of businesses owned by African Americans in Williamston. Marie Ellison Ford's precious picture of her father as a young boy with his family reflects a time only seen in history books. Firefighter brothers Steve and Phillip Ellison each wear a hero's identity through the legacy of protecting Williamston homes and businesses. A few hours with Carl Rogers turns into an enticing visual documentary. Dot Davis shares a scrapbook of old newspaper clippings depicting the centennial celebration and other historical events. Louise Morgan Ware, her brother Jody Morgan, and their uncle George Morgan tell of family bonds. James Link's prestigious career began with the National Advisory Committee for Aeronautics as a student in a woodworking class at Williamston High School. While serving as a volunteer at the mission store of Grace United Methodist (still located on Main Street), Nancy Autry shares stories of Deluxe Cleaners owned by her father and uncle for 40 years. As stories are told, the history, present day, and future of Williamston, South Carolina, connect to form a formidable society boasting strength, honor, and heritage.

Unless otherwise noted, all images are from the author's personal collection.

Introduction

An air of serenity surrounds the town of Williamston, South Carolina. Daily traffic flows through the historic town as children make their way to school and shoppers patronize local businesses. Day-to-day activity flows around the perimeter of Mineral Spring Park, the core of the town's intrepidity.

Anyone who travels the main artery through Williamston passes the historic park. Noted as one of the oldest parks in America, Mineral Spring Park remains as a landmark. Families, churches, schools, and clubs hold reunions, services, activities, and events in the park. Children play on the playgrounds and in the creek.

This was the aspiration of West Allen Williams, the farmer who dreamed of a healing spring. He foresaw the potential of his property in the mid-1800s and designated land for schools, churches, businesses, and houses.

Once a lively thoroughfare connecting Atlanta and Charlotte, Highway 29 was the main corridor taking travelers through Williamston's main street from the late 1800s through the late 1900s. During that time, the town held an assortment of grocery stores, department stores, cafés, pharmacies, and movie theaters.

Although many of the old businesses no longer operate, the town still offers a sense of dignity and worth to all who live and work there.

The town of Williamston is undergoing a revitalization to reconnect with the prosperous and genuine history of its founding. The vision of this revivification lies in a master plan of economic development and social engagement while listening to input from the community. The plan continues West Allen Williams's desire to create a path to envelop all who enter his town with a cloak of well-being.

When the older citizens of the town recall stories of growing up, their eyes sparkle and memories flow, spilling contentment and pride. The older storytellers were children during the early to late 1900s. They tell stories of seeing the first automobile ride through town. They tell about making ends meet when the mill shut down for a while and workers had no money to buy food. They recall desegregation and how everyone got along. They tell about going to war. The stories are numerous, amazing, and rich with detail.

Sarah Gossett Crigler, daughter of James Pleasant Gossett, wrote stories about growing up in Williamston. These treasured stories, in the possession of Julie Cole, are passed to each generation. The following excerpt from Sarah's stories shares a glimpse of how one family realized the fruition of West Allen Williams's dream:

> First, I must tell you about the home of my parents and the life there so that you will better understand our knowledge of and devotion to all the various animals and fowls, including the birds. About 1898, which seems a very long time ago to you and also to me, I was a little girl of 12. You just can't believe it, I know, but your mother once was young too and

went barefooted and ran and played with kittens and puppies and did all the other things, good and bad that you have done and that your own children will do. It was in this year 1898 that your grandfather built the home for his family that you as well as I have loved so much. It was called "The Oaks" because the house was set in a great grove of white oaks. Back of it lay 52 acres of land on which grew cotton and corn and there was a large pasture with a branch running through it where the cows were taken each day to graze. Around the house itself were the peach and apple orchards, the patches for sweet and Irish potatoes, corn and many other things. Then in the barnyard not far off lived all the cows, horses, mule, Aunt Edith's pony and all over the back of the place Granny raised chickens, turkeys, guineas, etc. to say nothing of the most wonderful vegetable garden, which was irrigated with ditches in summer. In the backyard was Judy's house and best of all Judy lived in it and we were allowed to visit her day or night for she had been our mother's nurse and before that had been deeded to our Grandmother Brown as her personal maid even before she was married. Judy was almost a feminine Uncle Remus for us children and we not only loved her but revered her. She called mom "hon" short for honey and was her joy and comfort until 1924 when she died. Presiding over all of this was your little Granny. Her observations and interpretations of the life around her should have been set down long ago by her children for someone to write into a book. She was a very wonderful and unusual person. She taught us and you to enjoy the life around us and to make events of the small doings of each day.

 I was almost forgetting to tell you what Williamston was like in those days. Lovely homes on wide shady streets, beautiful white clapboard churches with green blinds and high steeples, a fine male academy and a very noted female college. Resort hotels were crowded in summer with charming families and their children coming to enjoy the climate, the park in the center of the town, and to drink the fine mineral water. It was great fun to live there. We had many good winter friends, but in summer it was more exciting than ever with families coming time and again we made many friends from elsewhere. All through the summer there were ice cream festivals in the park with Japanese lanterns making things gay and tables scattered about where groups sat and ate and sang. Every month of winter, oyster suppers were served in a large upstairs hall. Williamston's notable cooks prepared and presided over our tremendous pots of elegant oyster stew. Fried oysters were a specialty—most elegant. There were many side platters of celery and pickle. Most delicious coffee—of course much gaiety. For fifty years "The Oaks," our comfortable home, was the scene of great hospitality. Our father's important business friends, our cousins, wonderful house parties of college friends and our three beautiful wedding receptions, with great crowds of young people staying in the house.

One
THE FOUNDATION AND EDUCATION OF WILLIAMSTON

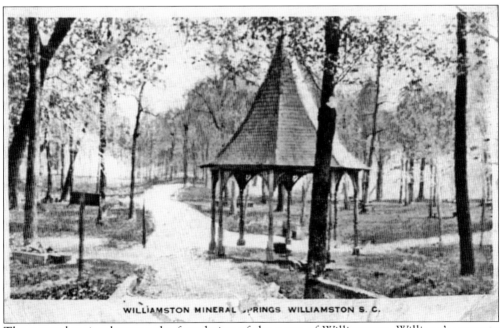

The natural spring became the foundation of the town of Williamston. Williams's property surrounding the spring formed the town. After having the springwater analyzed, Williams found the water contained medicinal minerals. News spread of the healing qualities of the water in what was called Mineral Springs, and people would visit to drink the water. In 1851, the Greenville & Columbia Railroad went through the area, allowing more people to visit. Incorporated in 1852, Mineral Springs became Williamston, named after its founder. (Courtesy of Connie Barnwell.)

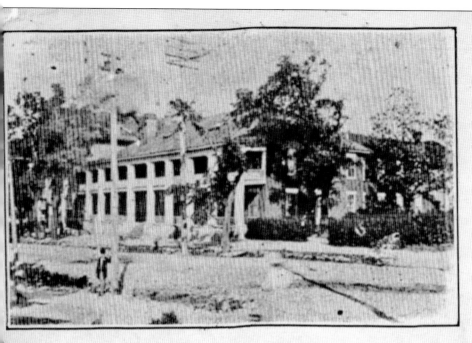

PARK VIEW HOTEL, WILLIAMSTON, S. C.

A hotel built near the spring was known as the largest building in the state at that time. The Mammoth Hotel had 150 rooms, along with bowling alleys and ballrooms. A fire in 1860 destroyed the hotel and other surrounding buildings. In the early 1900s, the former Lander College building became the Park View Hotel overlooking Mineral Spring Park. (Courtesy of Connie Barnwell.)

The dream of West Allen Williams included allotting land for churches and schools. Williamston has a rich history of educational excellence, with graduates reaching academic heights. The schools in Williamston taught students who excelled and influenced many parts of the world, serving in wars, working with the space program, and making strides for women. (Both, courtesy of Jean Taylor.)

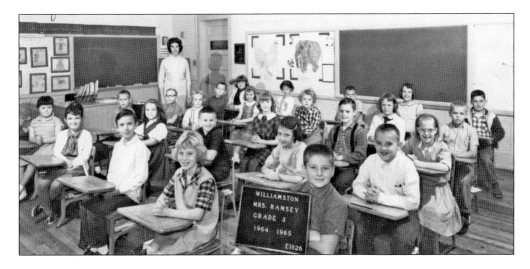

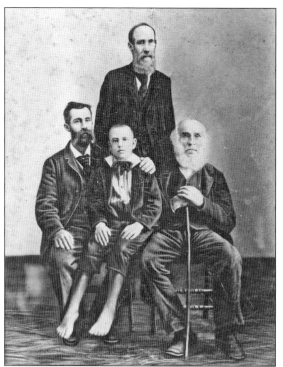

Pictured here are four generations of the Williams family. Standing is Richard "Dick" Williams, a brother of West Allen Williams. Seated at left is Richard's son Micah Berry Williams, and the young boy is John Williams. The man at right is unidentified.

Named for George Goodgion, the Goodgion School was located off Gossett Street near the train trestle. George Goodgion taught school in Williamston and then became the county superintendent of education. Located beside the Mineral Spring Park, the Goodgion School provided a central location for Williamston children to dream. (Courtesy of Julie Cole.)

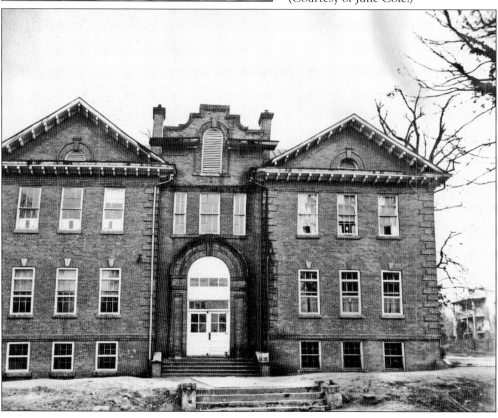

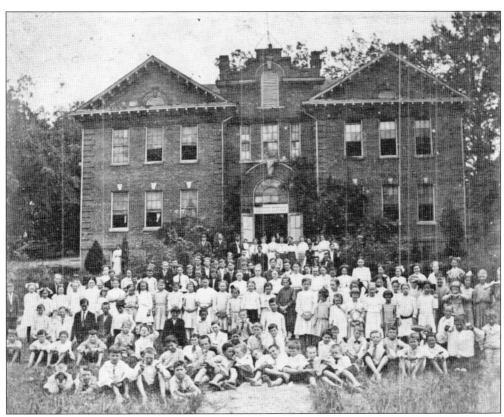

Louise Morgan Ware remembers playing on the train trestle at recess. "The library was in the basement of the Goodgion School," she said. "Before they were going to tear that building down, my daddy went down there and got some lights." (Courtesy of Vance Cooley.)

Louise Morgan Ware is pictured here around the age of 10. She would stop by Skipper Ladd's service station on her way home from school to buy a Coke for her and her brother. (Courtesy of Louise Morgan Ware.)

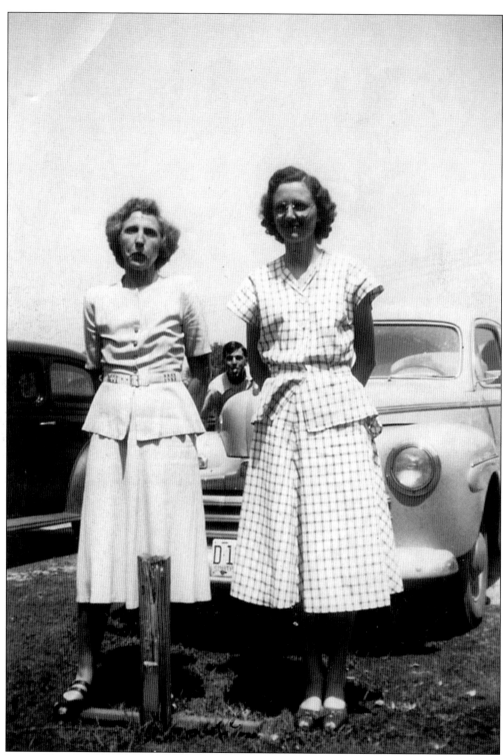

Pictured here are teachers Mrs. Elrod (left) and Mrs. Hunter. The young man in back is unidentified. (Courtesy of Jean Taylor.)

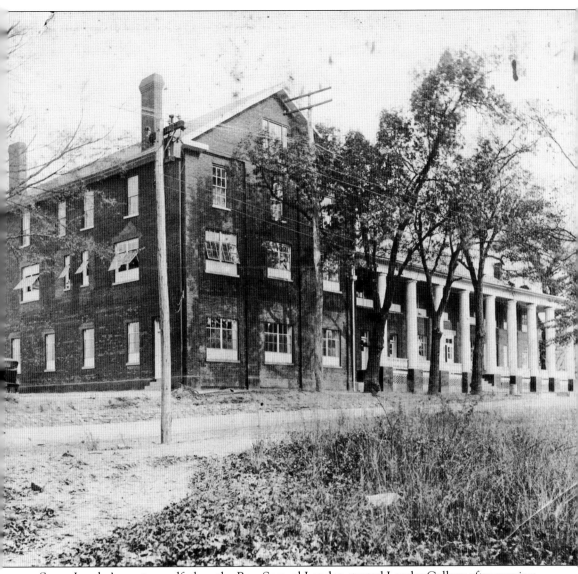

Susan Lander's great-grandfather, the Rev. Samuel Lander, started Lander College after moving to Williamston. Born in Lincolnton, North Carolina, Reverend Lander came to Williamston to serve as minister of Grace Methodist Church. According to James Link, Dr. Lander would walk to the mineral spring to get water every day. "He had a one-gallon glass jug for water," Link said. "The jug was a gold color inside from the mineral spring water." (Courtesy of Julie Cole.)

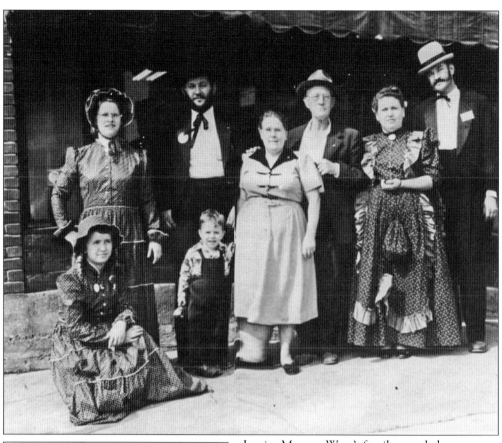

Louise Morgan Ware's family traveled to Tennessee to visit relatives. Notice that in observance of the centennial celebration, the family is garbed in the fashions of the 1850s. This level of civic pride continues in Williamston to this day. (Courtesy of Louise Morgan Ware.)

Pictured here is a family member of Williamston's founding father, West Allen Williams. (Courtesy of Connie Barnwell.)

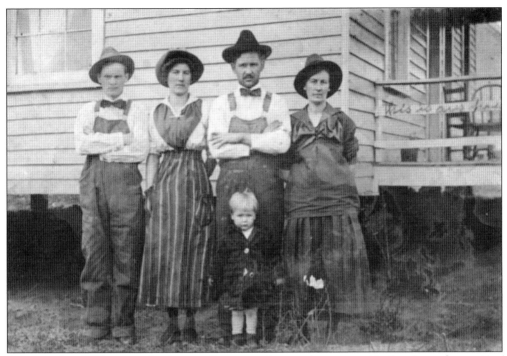

In bygone days, Williamston families usually remained regional, creating truly close-knit communities. Rarely would families need to venture farther than a few states away. Families in North Carolina, Georgia, Tennessee, and Kentucky, among others, often had close ties to Williamston. (Courtesy of Louise Morgan Ware.)

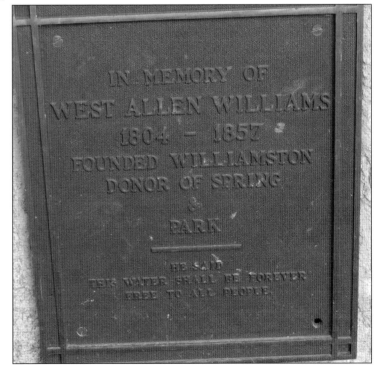

West Allen Williams wanted the area around the spring water to be set apart for the permanent "use, benefit, and behoof of the public on account of the known medicinal properties of the spring" and to "secure a pleasant, healthy, and agreeable resort to all persons who may visit the springs and town or who may settle and live there." (Courtesy of Jack Ellenburg.)

Lander College drew new residents to the town. According to a journal kept by a daughter of James Pleasant Gossett, the female students would parade down Main Street after attending church on Sunday mornings. In 1904, the college relocated to Greenwood, South Carolina, after which the building served as a hotel and an elementary school. Students no longer used the Goodgion School. Beattie Lee Hambright is pictured at left with Harrison Tucker. Below is teacher Nell Etchison with Harrison Tucker. (Both, courtesy of Jane Tucker Addison.)

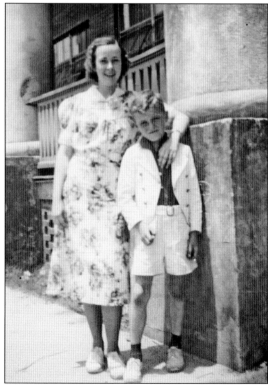

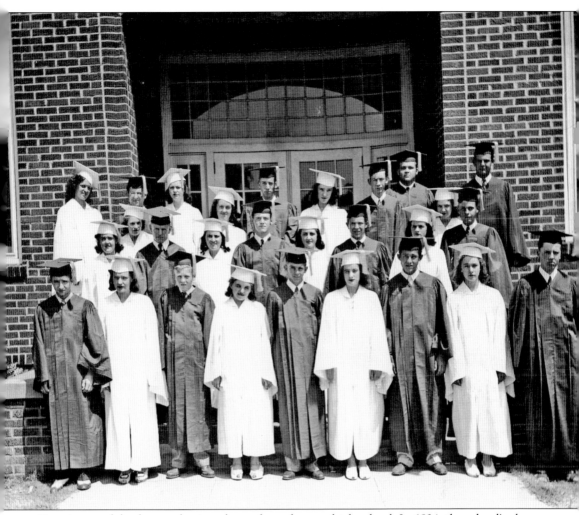

Here is one of the first graduating classes from the new high school. In 1934, the school's alma mater was written, to the tune of "Anchors Away," with the following lyrics: "Anchors aweigh, my boys. Anchors aweigh. Farewell to high school days. We sail tonight on life's deep blue sea. Through all our days in school, happy we've been. And now we set our sails and hope to find success and happiness." (Courtesy of Jane Harper Lawless.)

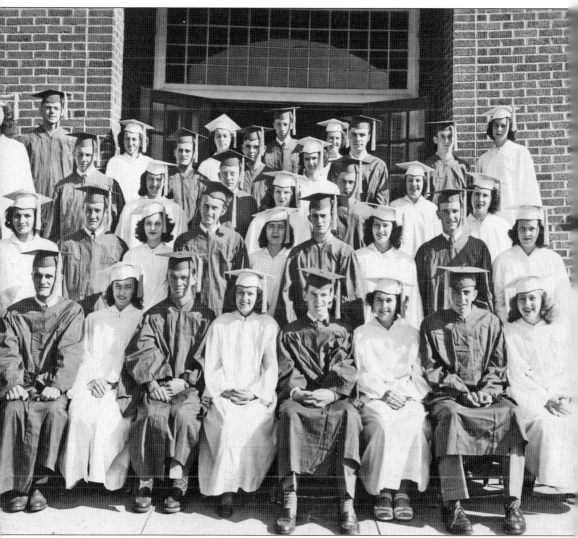

Shirley Harmon went to Gossett School in first grade and had Miss Bigby as a teacher. Shirley's family moved to Pelzer, where they lived until 1954, and then moved back to Williamston for her senior year. She said Mr. Phibbs and Thelma Taylor were her favorite teachers. (Courtesy of Julie Cole.)

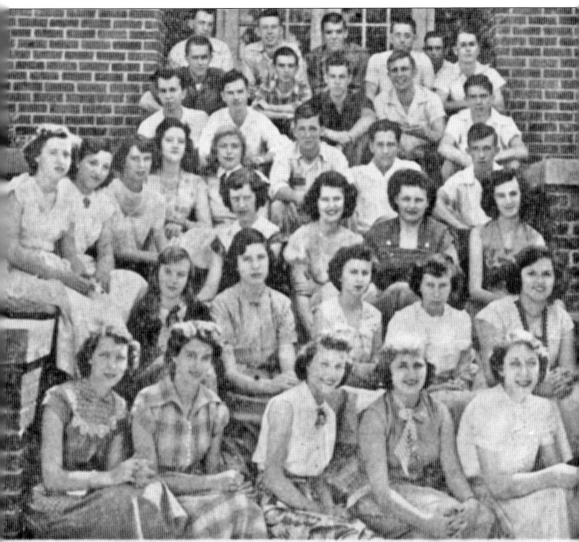

illiamston High Senior Class—Jane Anderson, Joan ock, Betty Davenport, Evelyn Hankins, Victoria awkins, Ruby Hiott, Shirley Mark, Libby Michael, zabeth Patterson, Betty Phillips, Martha Phillips, an Rainey, Zoie Ruth Rainey, Dot Roberts, Chris- e Rogers, Margaret Stone, Bobbie Tollison, Carolyn atkins, Ellen Williams, Katie Gilreath, Jack Bell, Billy Bobo, Alton Boggs, Buddy Burns, Bobbie C well, Bryson Copeland, Leon Cox, Truman Elli Ray Ellison, Dewey Gambrell, H. A. Griffith, Ke Guthrie, Dean Horne, Charles McJunkins, Ge Mullikin, Eugene Owens, Jimmy Sargent, Billy Selman, Archie Whitt, Jimmie Woods.

Barb Wentzky was in the first class to graduate from Palmetto High School in 1954. She said she really liked all her teachers, especially Margaret Hunter, Frances Elrod, Billy Lander and his wife Ollie, Ruth Wood, Thelma Taylor, and Kathleen Nelson. Barb said she keeps up with many of her best friends from school, including Barbara Hawkins Bradshaw, Alvia Sue Boiter Kellett, Floyd Rogers, Bill Harvey, Ben Ford, and Leon Pack. (Courtesy of Julie Cole.)

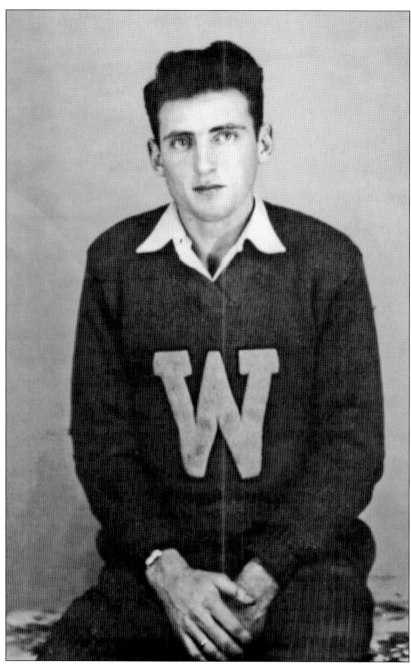

James Link describes going to school in Williamston as "most good." He graduated in 1942. Here, he is seen wearing his senior sweater bearing the football letter. "Sometimes we would scrimmage the alumni," he said. "They were big and older men. One day, we were playing a scrimmage game and my opponent was a tall guy with big hands. I could not get by him. I said to myself, I know what I will do. We were wearing helmets. I thought I would lower my head for a lunge and put my head in his stomach. He saw what I was doing and cupped up those huge hands and fingers. That's where my head hit. It almost drove my head through my shoulders. No more of that." (Courtesy of James Link.)

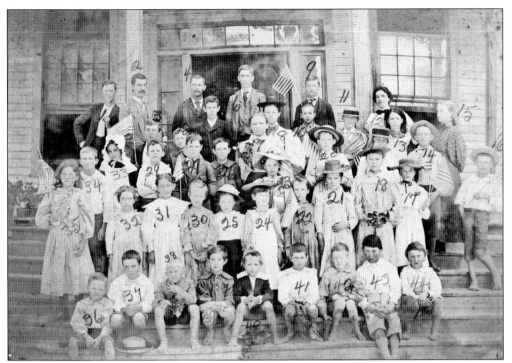

Schoolchildren pose for a patriotic occasion in the early 1900s. The numbering that appears on the image is how people in photographs were most easily identified in those days. (Courtesy of Vance Cooley.)

Lasonya Owens said Ms. Hayes was her first grade teacher. "She was the best," she said. "In high school, Mr. Phibbs was vice principal. Everyone loved him. Thinking back through all my years in school, there were many great teachers, too many to mention. But every one was a big part of my life." (Courtesy of Julie Cole.)

"We didn't have any means of getting to school—either walk or run. We did both," James Link said. "We grew up on a farm outside of the mill village. It was a good life. Had a lot of good times at school. A lot of good friends. Ted Hampton was one of my best friends. He and his brother Homer. We were all in the same class together. We walked through the parking lots. There was a trestle on the Southern Railroad. It went across the creek by the park. There were two Rentz brothers. One, Watson, was in my class. And the other, J.C. Jr., was in my brother's class. It turned out in World War II, J.C. was in the Army Air Corps on Guam where I was. He was a pilot on one of the big bombers, B-29. He made several missions over Japan. The Rentz family lived on a farm in Williamston through town toward Anderson at the bottom of the hill past the school, cross the creek, turn right, go around a little curve left, they lived there." (Courtesy of Jean R. Taylor)

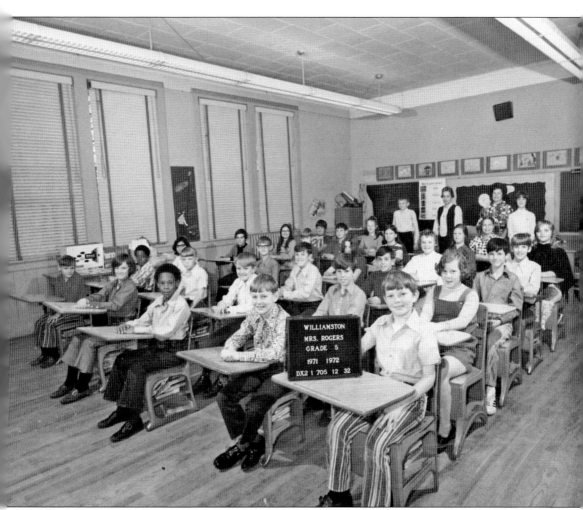

The Link brothers provide the following history: "One of our high school classes was the wood shop taught by Superintendent A.B. Hair Jr. During World War II, the Navy somehow contacted Mr. Hair and asked him to make them model fighter planes they could use for identity purposes. We did. Then we learned that the Langley Air Force Base in Hampton, Virginia, had openings for employment. They needed model makers there at NACA. They had an apprentice school there. We got the job. I got the model shop and Edgar got another section." (Courtesy of Jean R. Taylor.)

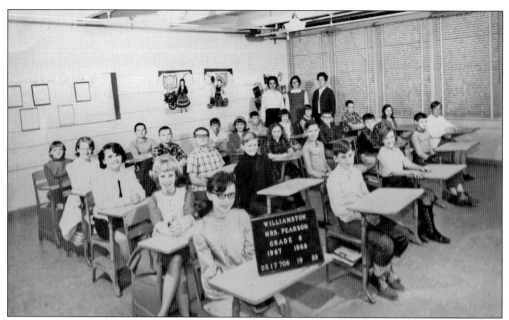

James Link credits his education from Wiliamston as launching his career with Langley Air Force base. There were several wind tunnels at the Langley National Advisory Committee for Aeronautics (NACA). Engineering would design new airplanes or redesign the old ones through models James Link had helped to make. After each model was made, the engineer would set it up to be tested in the wind tunnel, which would replicate any conditions that an airplane could encounter in the air. Link said any airplane seen today went through NACA Langley. (Courtesy of Jean R. Taylor.)

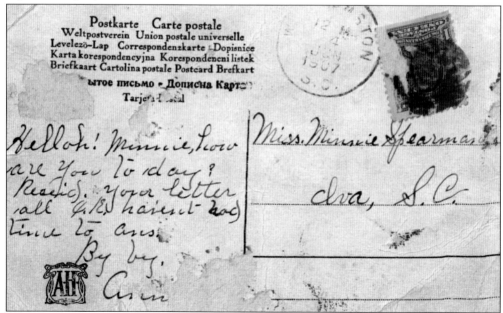

This is a vintage postcard from the early days of the Mineral Spring Park. More than just a souvenir, postcards in those days were important ways of keeping track of friends and loved ones during their travels—a peace of mind often taken for granted today. (Courtesy of Connie Barnwell.)

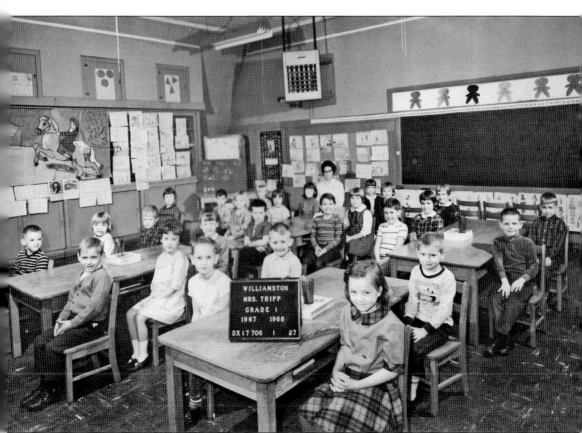

James Link shared the following information about former classmates. The Rev. Carl Grayson Ellison and Sgt. Frank Cothran graduated from Williamston High School in 1941. Ellison served as a fighter pilot in the Army Air Corps during World War II. The Rev. James Homer Hampton and Thomas Fred Hampton graduated from Williamston High School in 1942 and served in the Army during World War II. Lt. Abram Young Bryson, from Laurens, South Carolina, was a Williamston High School teacher and football coach. He also served in the Army Air Corps during World War II. His wife, Martha Davis, graduated in 1941. (Courtesy of Jean R. Taylor.)

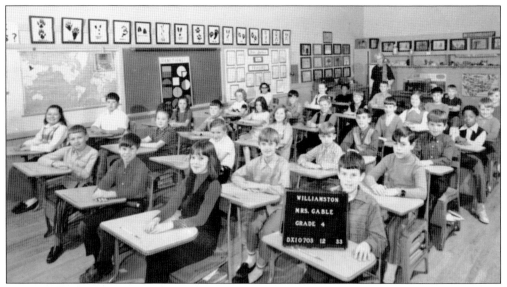

James Link graduated from Williamston High School in 1942. His brother Edgar graduated in 1941. James served in the Army Air Corps during World War II. Stationed in Guam, James was a B-29 mechanic whose main job was to keep the B-29s flying missions over Japan. After completing basic training at the Keesler Air Force Base in Biloxi, Mississippi, his class took a train to Seattle, Washington, where they were admitted to the Boeing factory's B-29 mechanics school. James then took a train to California to board a troop ship, and 17 days later, they anchored in Guam. (Courtesy of Jean R. Taylor.)

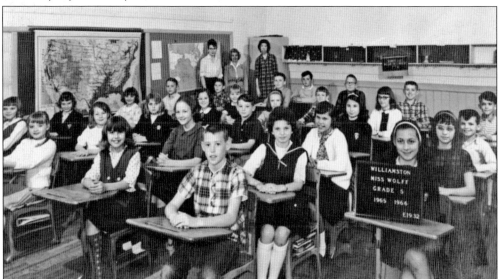

Connie Barnwell recalls when she worked with the school system: "I went to work at Williamston Elementary the first day of the 1979–1980 school year. It was Julia Mancino's first year as principal. She was a super lady. She was a principal that you would not always agree with her, but you always respected her for who she was and her work. She is no longer with us, but I will never forget her kindness of care for the students and those working under her. Our school district lost a great lady when we lost her. She was the last principal at Williamston Elementary before it was closed and joined with Palmetto Elementary." (Courtesy of Julie Cole.)

Two
VISION BRINGS PROSPERITY

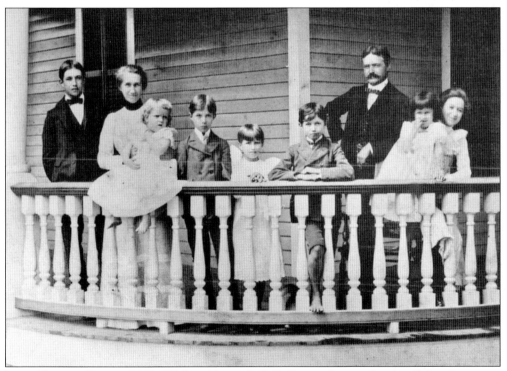

James Pleasant Gossett (1860–1936) and his wife, Sally Brown Gossett, lived on Pelzer Avenue in Williamston. Their house was known as the Oaks. James was instrumental in opening the first cotton mill in Williamston. The Gossetts were a prominent family in the cotton textile industry for several generations. James was a founding member of the Cotton Textile Institute and an owner of several textile mills. His son Benjamin Brown Gossett managed several of the family mills, and during World War II, some of these mills won the "E" Award for excellence. Benjamin sold the majority of his stock to Textron in 1946 and retired from the industry the following year. A nephew of James, Paul Gossett, was an orphan. He came to live with James and Sally. Later, Paul became the paymaster for the cotton mill. (Courtesy of Julie Cole.)

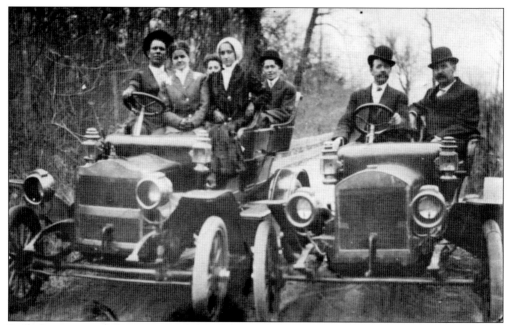

Packed into state-of-the-art automobiles of the time, the Gossett family made a trip to Charleston, South Carolina. The Holy City is still a popular weekend destination for residents of Williamston. (Courtesy of Julie Cole.)

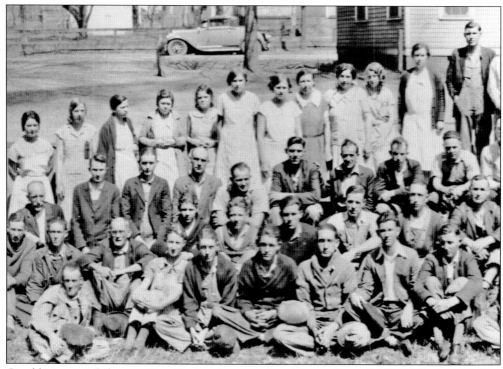

Gerald Morgan's father was 9 or 10 when he started working at the mill. "Daddy had a little box he would push down the alley and lay up roping. The people that lived uptown made their living off of us." (Courtesy of Jody Morgan.)

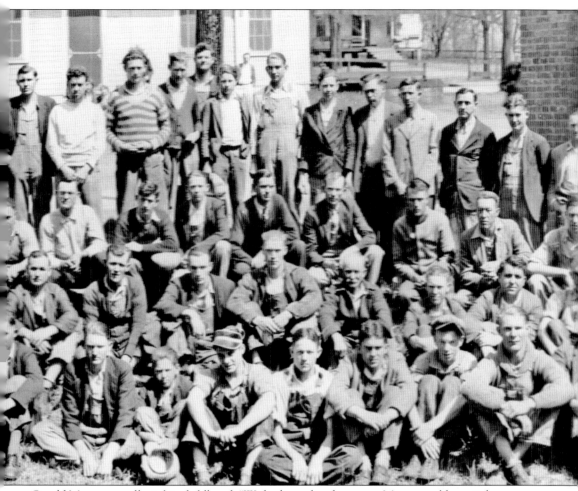

Gerald Morgan recollects his childhood: "We had wooden doorsteps. Mama would say sit down on the doorsteps. She always gave somebody a biscuit and a fried egg. On Sunday morning, we had steak gravy and a butter biscuit. Mama would buy a pound of steak, take an old plate and pound enough for all of us to have a little piece of steak. By the time we had that pan full of biscuits ate, she had another pan of biscuits ready." (Courtesy of Jody Morgan.)

Gerald Morgan said, "I went to work when I was 16. All of my siblings worked in the mill. When I came back from World War II, I left Williamston, went to Seneca, where my wife's family lived. I met my wife when she came to Williamston to work in the mill to make money to send back to her daddy. My wife's name was Ovalyne. Mary Louise's daddy turned down a scholarship to Clemson College to help Daddy work in the mill. He quit school to work in the mill." (Courtesy of Jody Morgan.)

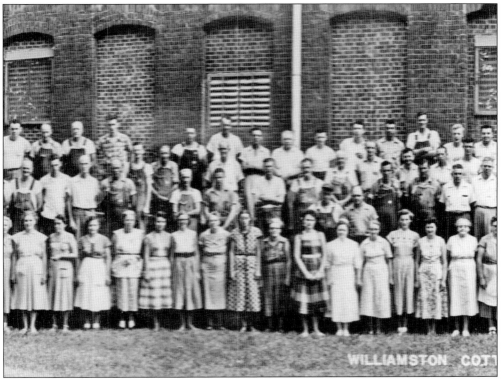

"The mill store sold out to a man who came from Anderson and ran the store," Gerald Morgan said. "There was another store, Eleazer's, across from the armory. The mill store was at the end of the mill where they played movies. It cost a dime to see Charlie and Bill Monroe perform on top of the mill store." (Courtesy of Jody Morgan.)

Here are the humble beginnings of Hillcrest Church. When the mill church split, two new churches formed: Calvary Baptist and Hillcrest Baptist. (Courtesy of Jane Harper Lawless.)

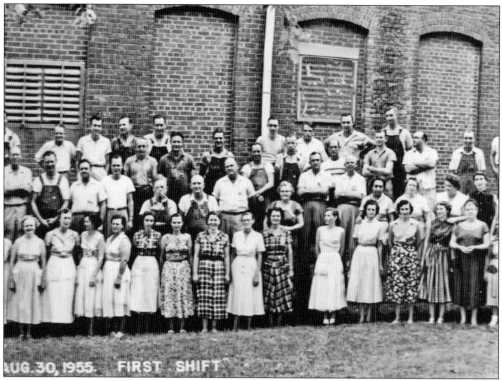

Carl Rogers said, "My father worked at Mount Vernon. Mill workers were paid in tokens, which they would take to the mill store. Everything you needed was at the mill store. Francis Wilson started working at the mill store and ran the meat market. We had a four-room house on First Street that cost 10 or 15¢ a month. Take home pay was $7.50 a week. We went to the church, Gossett Memorial, behind the mill pond. Hillcrest Church and Calvary Church formed from Gossett Memorial." (Above, courtesy of Jody Morgan; below, courtesy of Jane Harper Lawless.)

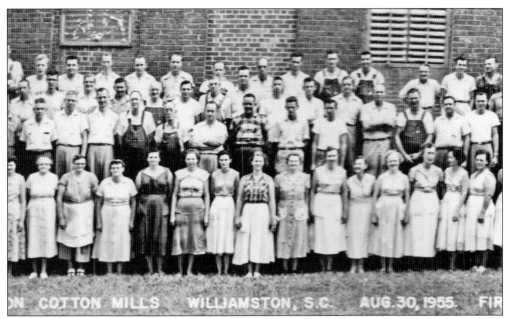

"When I was working at Francis Wilson's, I was 14 and making $2.75 a week working Thursday and Friday afternoons after school," Carl Rogers said. "I worked from 7:00 a.m. to midnight on Saturdays delivering meat. In the 1940s, Francis Wilson would go every Friday to the company mill store. He had regular customers in the mill village who didn't have transportation. He would write down orders and would call to the market to tell me where to meet him. We would deliver meat. Sometimes I would deliver groceries on my bicycle. I drove up to Woody Welborn's and always go around to the back of the house. Behind the police department, near where the first ball field is, there was a cannery potato house in Williamston in the 1940s. All the farmers would bring their potatoes there to store. Farmers would bring fruits and vegetables to the cannery to can them." (Both, courtesy of Jody Morgan.)

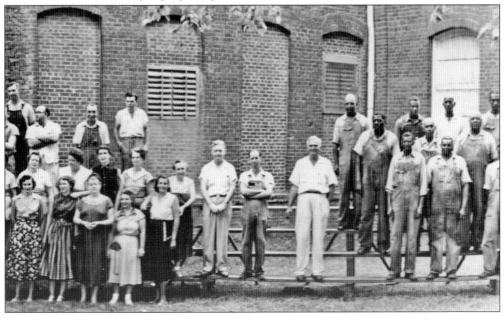

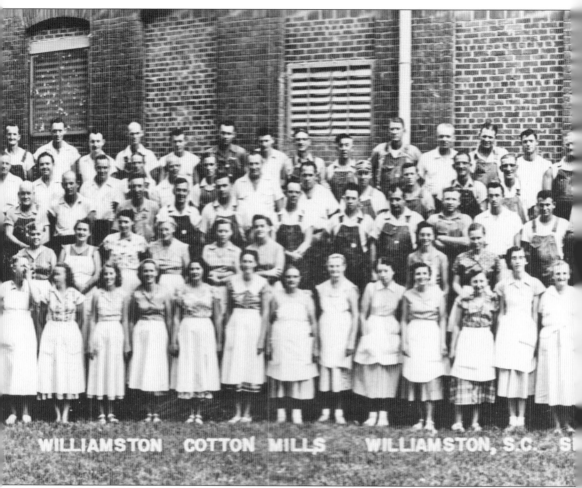

"If you lost your job at the mill, you didn't have a place to sleep that night," Carl Rogers said. "They gave you a certain length of time to move out. Also, you bought your stuff from the company store. My mother said she bought an iron from the store and paid a quarter a month. They were making less than $6 a week. After I was born she went back to work. When she got her first paycheck, she was so relived they could pay the company store off." Jackie Robinson went to work in the mill after graduating from high school in 1972. He was one of the first young black men to work in the mill after desegregation. After working about six weeks, Jackie lost his right eye when a spring popped off of a loom and pierced his eye socket. Despite the accident, Jackie healed and continued to work in the mill for several years. (Courtesy of Jody Morgan.)

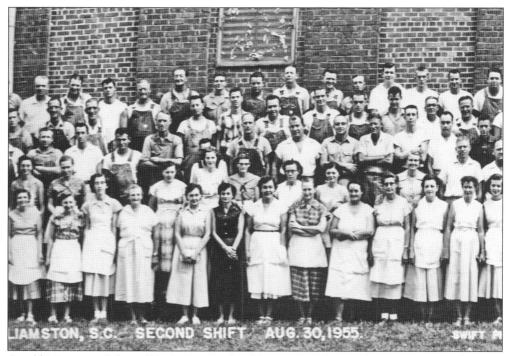

Gerald Morgan said the mill had a barnyard and hog pens in the woods. Pipes ran from the pond behind the mill into the boiler room. The combination of water and coal heated and operated the mill. (Courtesy of Jody Morgan.)

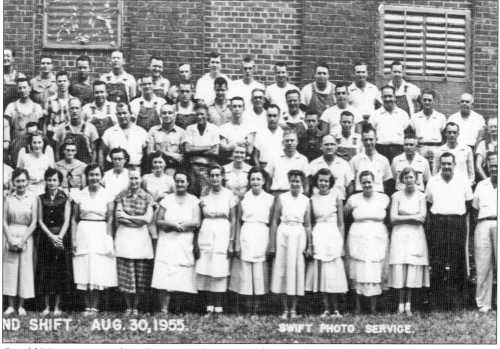

Gerald Morgan remembers Frances Wilson going door-to-door to take orders. He would take the grocery lists, fill the orders, and then deliver the items. (Courtesy of Jody Morgan.)

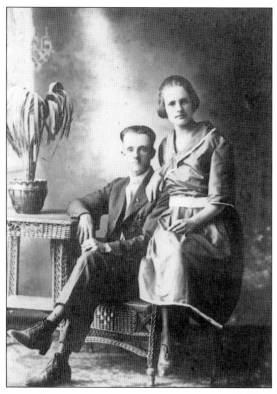

This photograph, taken at Snipes Studio in Pelzer, South Carolina, on June 30, 1921, shows Luther Talmadge Stone and Ellie Marie Cummings Stone, grandparents of Dianne Eskew. Married on June 19, 1921, they lived on Third Street in the mill village until they bought a farm off Big Creek Road. Their rock house on the farm is still standing. Dianne Eskew's father, Albert Buddy Stone, told her they hauled those rocks from the fields around the house and rocked the house themselves. He also said the house was a log house before they added the rocks. (Courtesy of Dianne Eskew.)

Pictured here are Robert and Anna Smith Cummings, parents of Williamston native Ellie Marie Cummings Stone. Robert and Anna were well-regarded farmers in the early days of Williamston.

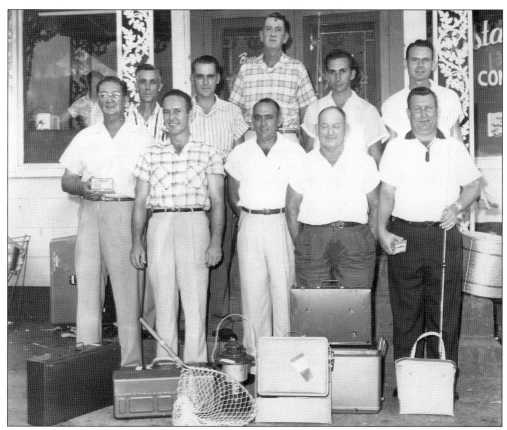

Stocking up for an extended fishing trip, residents of Williamston pose for a commemorative photo in front of the Palmetto Beacon, a restaurant located where Kenny's Home Cooking is now. Willie Smith originally opened the restaurant when Route 29 was the main road north to south, before the construction of Interstate 85. From left to right are (first row) Mr. Sears, three unidentified, and Rowland Mahaffey; (second row) unidentified, R.A. Shaw, unidentified, Lloyd Rowe, and unidentified. (Courtesy of Jane Harper Lawless.)

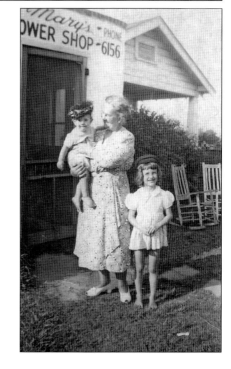

Jane Harper Lawless said, "My mother, Mary, owned a flower shop. In this picture is my grandmother Harris holding Dick, Uncle Larry's son, and me standing beside them." (Courtesy of Jane Harper Lawless.)

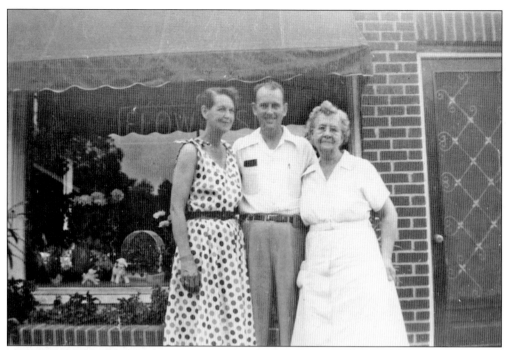

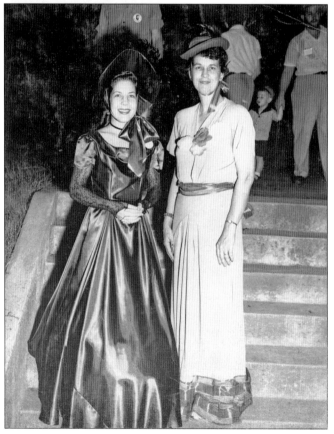

"Pictured here are my mother, Mary Harper, my grandmother Harris, and Uncle Larry," according to Jane Harper Lawless. "Larry lived in Washington, DC, and eventually only came home twice a year. This photo was taken in front of mother's flower shop. Lou Jordan Dacus made a quilt using ribbons from Mary's Flower Shop." Although these ladies are unidentified, their genuine smiles reflect the spirit of Williamston residents. Dressed in centennial attire, the town residents cherish their heritage. (Both, courtesy of Jane Harper Lawless.)

Mary Harper is shown sitting on a planter in front of her flower shop. It is not clear how old she was at the time of the photograph. (Courtesy of Jane Harper Lawless.)

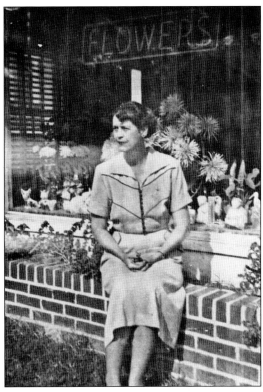

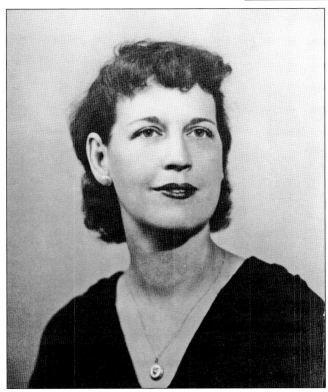

Pictured here is Mary Harper. She was born in 1906. She would marry her husband, Pete Harper, in 1924.

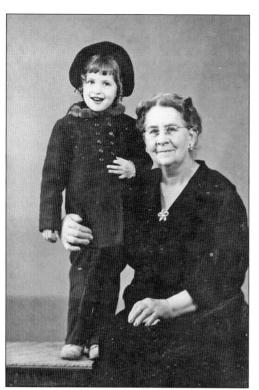

Jane Harper Lawless is pictured here with her grandmother Mary, featuring two generations of Harpers. (Courtesy of Jane Harper Lawless.)

Louise Morgan Ware went to work at Pelzer Williamston Bank in 1962. From left to right are (first row) unidentified, Louise Morgan Ware, Janice Mulliken, Jean Hankins, Pat Watson, unidentified, Roberta Kuykendall, unidentified, and Pete Williams; (second row) Hazel Cowan, Betty Roberson, two unidentified, Will Hopkins, Jean Davis, and unidentified. (Courtesy of Louise Morgan Ware.)

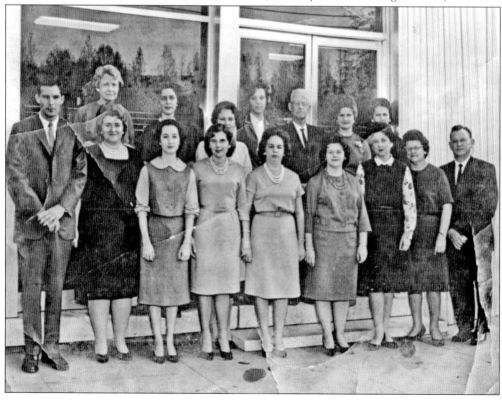

Julie Gossett Cole attended Mrs. Terry's home kindergarten. It was located in the Terry house, next to Little Caesars Pizza and across the street from the clock on Main Street.

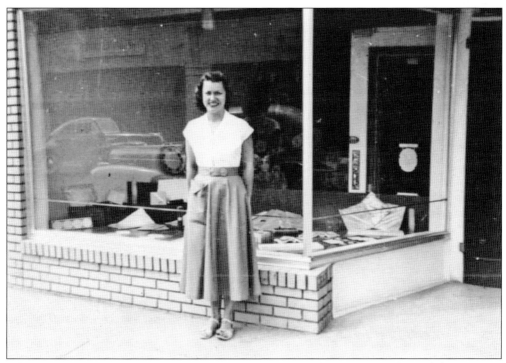

Julia Gossett is pictured in front of Attaways Office Supply. (Courtesy of Julie Cole.)

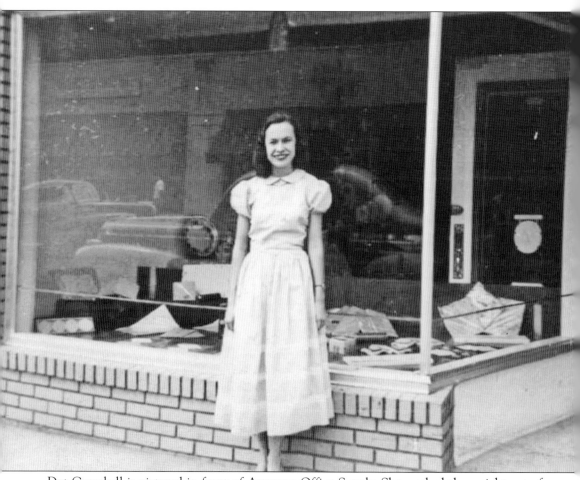

Dot Campbell is pictured in front of Attaways Office Supply. She worked there right out of school when she graduated from Erskine College. Jack Ellenburg said, "I bought my Smith Corona Typewriter at Attaways. It came with a hard-shell carrying case. I was working at Bean's Drive-In as a curb hop making $12 a week plus tips. I paid $9 for it. They threw in a metal, portable, rolling typing table." (Courtesy of Julie Cole.)

Van Leopard's father owned a Gulf Station in Williamston from 1954 to 1981. Several gas stations and auto repair shops were in business in the Williamston area. Whittney Garage was a helpful, trustworthy resource for Williamston residents with car trouble. However, rarely would they show up with problems as severe as this.

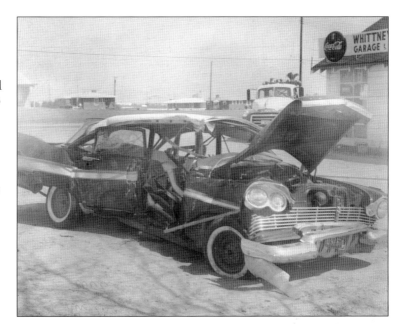

Jean Taylor said her father would take her to the movie on Saturday. In addition to showing movies, the Williamston theater provided a rehearsal place for local bands. The name of this group is unknown, but local rock stars the SoulSpirations often played on stage at the movie theater. (Courtesy of Jane Tucker Addison.)

Faith Manley is pictured at the former Williamston theater. Wayne Philips said, "The theater was the place to be on Saturday night. I made lots of memories there." Mike Jackson said, "We would go to the theater every Friday and Saturday when I was young. Ricky Gilliland used to shine the flashlight in your eyes when you were cutting up or making out." (Courtesy of Jane Tucker Addison.)

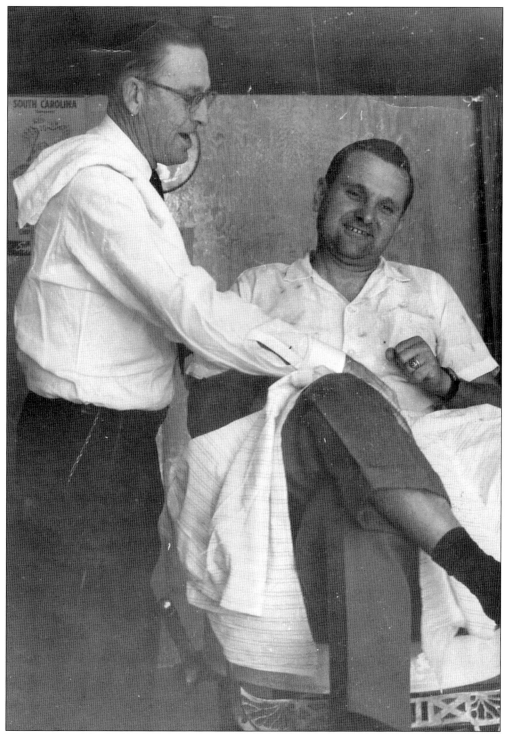

With a clean, close crop and a fresh shave, this Williamston man is a satisfied customer. In Williamston, barber shops were a valued meeting place and source of camaraderie for local men. (Author's collection.)

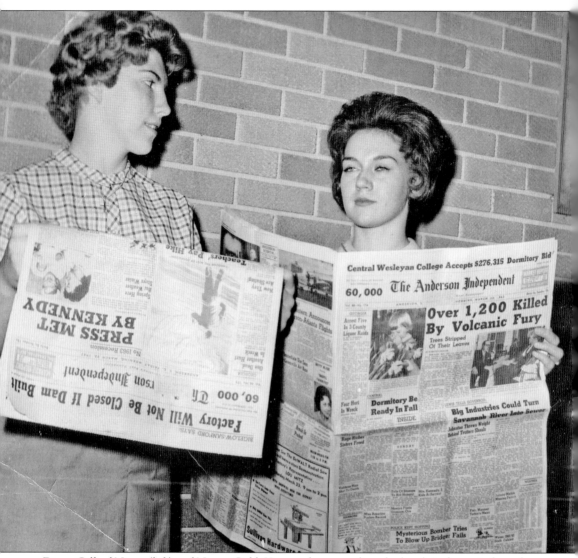

Diane Gillard Neves (left) and Nancy Cobb Kay are shown reading the local *Anderson Independent* newspaper. One paper is dated March 22, 1963; the other is dated March 23, 1963. Diane graduated from high school in 1965. Nancy graduated in 1964. (Courtesy of Jane Harper Lawless.)

Three

BUSINESS DRAWS GOVERNMENT

This is a receipt from the office of the city clerk and treasurer. Williamston resident J.H. Ray paid $3 in taxes in 1922. (Courtesy of Louise Morgan Ware.)

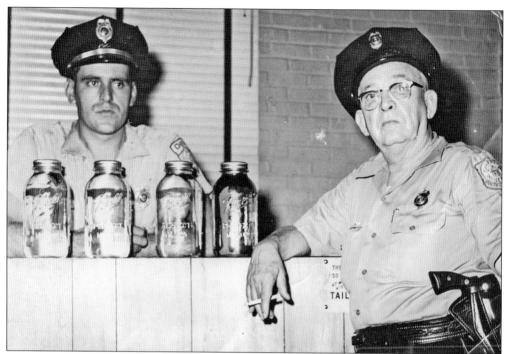

In any small town, rumors flow of moonshine and police regulation. Jack Ellenburg said of the photograph above, "The one on the left is R.A. Shaw, and the other one is Mr. Murphy. He was very short in stature, and round. I'm not sure about the booze, but we did have a few people that were known moonshiners. I had heard my brother talk about moonshiners slipping it to the workers in the mill. They would sell it by the quart. They would meet in the parking lot after they got off the second shift and buy a bottle. They also caught the workers on the third shift going to buy it. There were people working in the mill that were kin to the police." (Both, author's collection.)

Pictured here is Louise Morgan Ware's great uncle J.H. Ray, who married Bonnie Metcalf. Louise said the Metcalf family came to Williamston to work in the mill. They lived on First Street behind the mill. Louise's mother, Nora, and her twin sister, Nola, came to live with the Metcalfs and also worked in the mill.

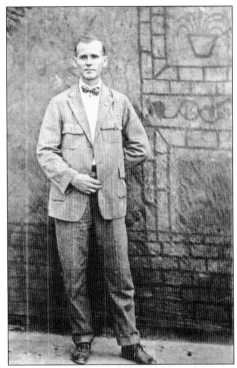

Posing for this portrait are family members of Bonnie Metcalf from Tennessee. Frequent travelers, the Metcalf family split their time between Tennessee and Williamston. (Courtesy of Louise Morgan Ware.)

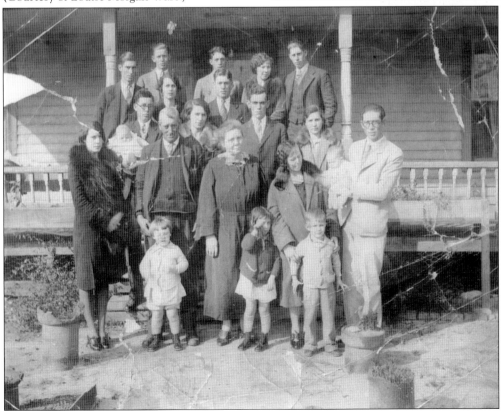

This picture shows Bonnie Metcalf Ray. She and J.H. Ray met and married in Tennessee before moving to Williamston. An established citizen of Williamston, J.H. Ray participated in town business. He was registered to vote in the municipal election of February 17, 1923. (Courtesy of Louise Morgan Ware.)

This public road tax receipt, dated November 29, 1915, belonged to J.H. Ray. It shows he was living in Unicoi County in Tennessee at the time.

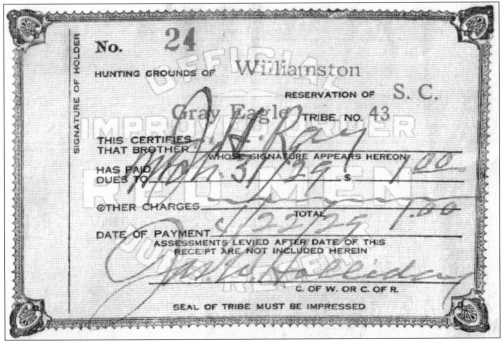

Inspired by the Boston Tea Party, the Improved Order of Red Men claims to be the oldest fraternal organization in America. Tracing its origins to 1776, the group's members claim to be descendants of the Sons of Liberty. Promoting allegiance to the flag and preserving freedoms, they patterned themselves after the Iroquois Confederacy and its democratic governing body. South Carolina currently has no active tribes. (Above, courtesy of Louise Morgan Ware; below, courtesy of Steve Ellison.)

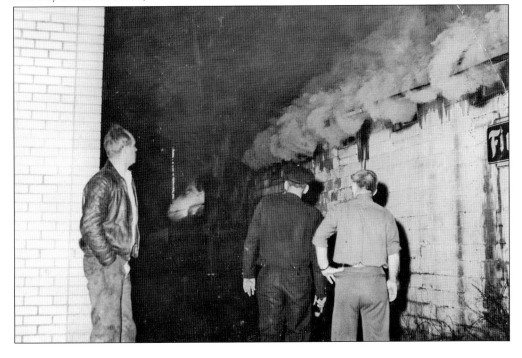

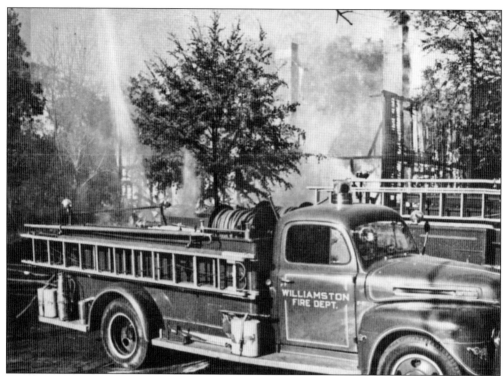

The all-volunteer Williamston Fire Department is a respected part of the community and across the state. Rated in the top 3.7 percent in the nation, the department received an Insurance Service Organization (ISO) Class 3 rating. The ISO bases a department's rating on many factors, including the number of personnel on duty, their training level, the amount of water the department can get to a fire, and the amount and quality of equipment used. The purpose of the ISO is to give insurance companies a uniform system on which to base their premiums. The current fire station was dedicated on October 19, 1980. The station still houses the original fire truck, a fully restored 1936 Chevrolet engine that is used for parades and special events. (Both, courtesy of Steve Ellison.)

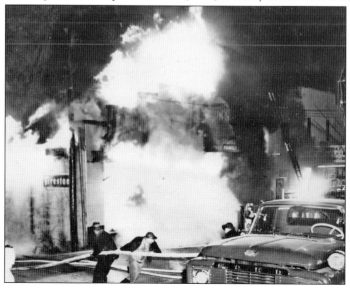

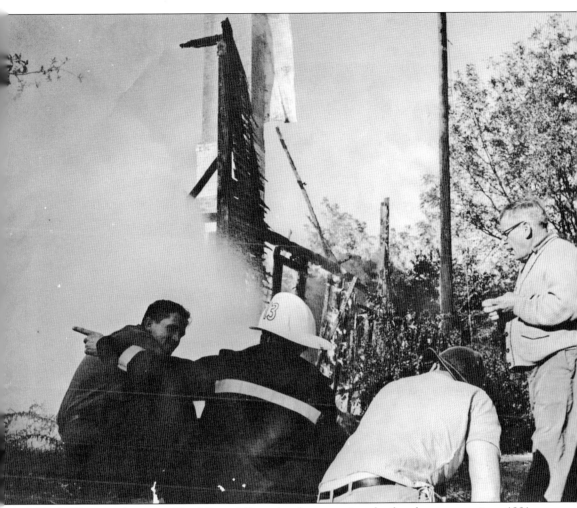

With 25 years of service, Chief Steve Ellison has been serving the fire department since 1991. Assistant Chief Tim Farmer has served since 1985, Capt. LaDane Baker since 1980, Capt. Van Ellison since 1999, Lt. Rick Heatherly since 1990, and Lt. Dave Bryant since 2003. Lloyd Crowe has served since 1964; Phillip Ellison, 1972; David Rogers, 1973; David Harvell, 1974; Russ DeAngelis and Harold Nichols, 1992; Robbie and David Owens, 1994; Patrick Baker, 1995; Allen Ellison and Robbie Bolden, 2001; Julia Nichols, 2002; Jason Crist and Timmy Heatherly, 2007; Brian Austin, 2008; John Friar and Sonny Lyle, 2010; Kevin Winn, 2012; Steven Donald, 2014; Justin Davis, Mitch Harbin, Steve Carraway, and Brandon Parham, 2015; and Kyle Strickland, 2016. (Courtesy of Steve Ellison.)

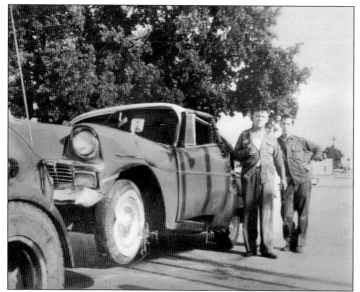

These two young mechanics were always on hand at a local garage that residents relied on to keep their automobiles up and running. The vehicle pictured here was typical of the era. (Courtesy of Jean Taylor.)

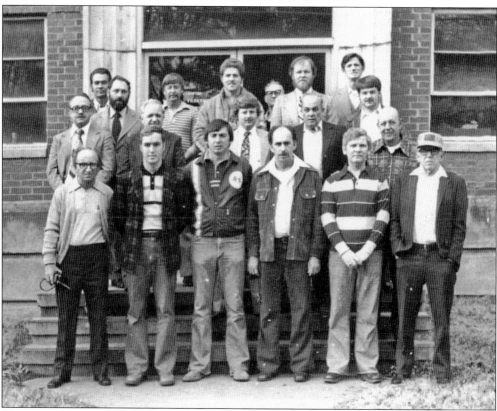

Shown in this 1972 picture are, from left to right, (first row) Tommy Walker, Van Leopard, Phillip Ellison, Loyd Crowe, Billy Harper, and Marvin Rogers; (second row) Red Lollis, Hovie Canup, Jimmy Rogers, Doug Thomason, and Earl Owens; (third row) Sidny Lafond, Williamston Wesleyan, William Reid, Keith Rhodes, David Harvell, and Mike Smith; (fourth row) Raymond Roach, Rudy Vanidore, and R.L. Saxon. (Courtesy of Steve Ellison.)

Four
Stories of Healing, Friendship, and Camaraderie

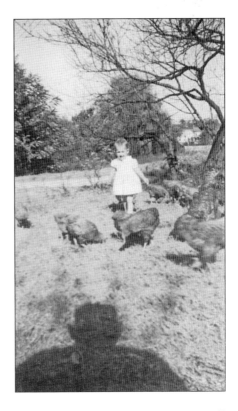

Jane Harper Lawless said of this image, "That is me in the backyard of our house, chasing chickens. It seems unbelievable now that we lived on Main Street and had chickens in the backyard. When I was six years old, I was bitten by my dog with rabies. The dog was foaming at the mouth. The vet wouldn't touch the dog. I had to take 13 shots. It turned out I was allergic and was paralyzed. My parents took me to Anderson Hospital. They said there was nothing they could do. My dad was a brick mason then and had recently finished working at Duke University. Snook Smith worked at the funeral home and used their ambulance service to drive me and my mother to Duke. The doctors told my mother that they were sure they could help. They had tried a new drug on two people who had died. I was there 12 days while they gave me this new medicine. Here I am today. It was the people of Williamston who prayed for us that spared me. People sent toys and gifts. Thank God I was spared. I am very thankful I grew up in Williamston." (Courtesy of Jane Harper Lawless.)

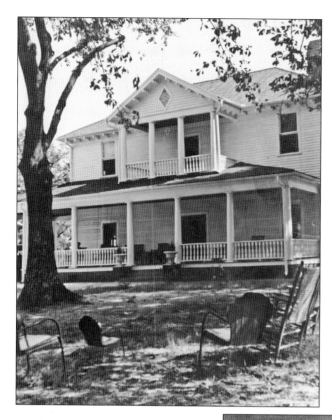

Dave Tucker built a home closer to the town of Williamston so his children could attend school there. The house was built around 1916. It became the home of Harrison and his bride, Sue, following his father's death. (Courtesy of Jane Tucker Addison.)

Mary Sue Brown Tucker married Harrison Tucker. She was an active member of the Big Creek Baptist Church, the All-Together Club of Williamston, and the Anderson County Women's Club. She also taught kindergarten at her home. (Courtesy of Jane Tucker Addison.)

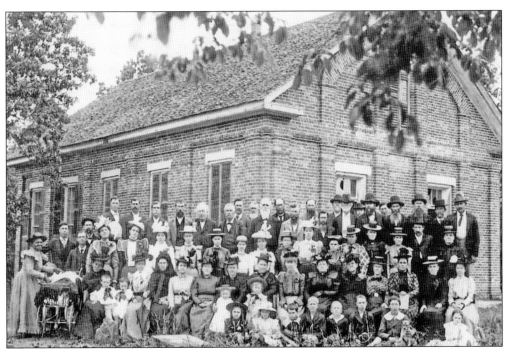

The congregation of Big Creek Baptist Church is pictured here in 1898. Organized in 1798, the church welcomed slaves into the congregation. (Courtesy of Sarah Jo Bargoil.)

This photograph shows Zoie Ruth Rainey Webb standing near Mineral Spring Park in the early 1950s. Mineral Spring Park remains a place of peace, friendship, and well-being. (Courtesy of Jean Taylor.)

Christmas in Mineral Spring Park is a tradition for families. Each year, residents, businesses, and town representatives decorate the park for the holidays. (Author's collection.)

In this photograph, Brooks Vaughter was three or four years old. Many remember this piece of playground equipment in Mineral Spring Park. Dale Campbell said he has a scar on his chin from playing on it. (Courtesy of Jean Taylor.)

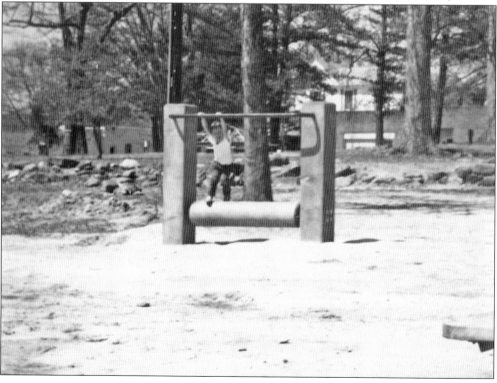

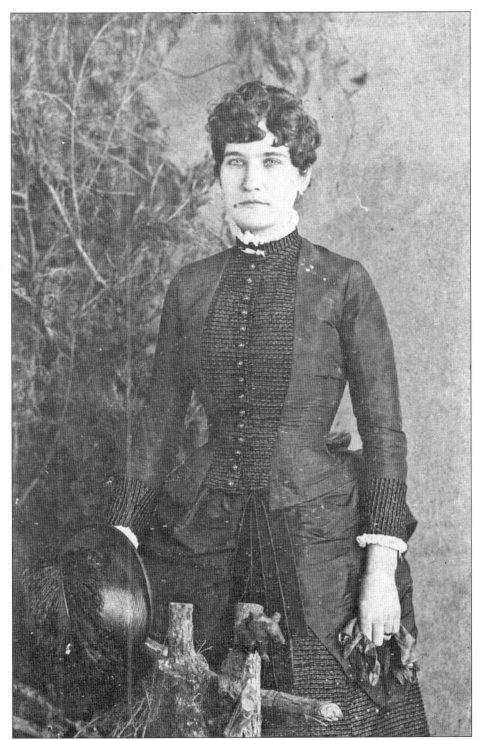
Pictured here is Lora Talbert Milwee's mother. Her Victorian garb, capped off by her feathered hat, contrasted with the bucolic backdrop. This is a perfect snapshot of the life and style of Williamston during that era. (Courtesy of Connie Barnwell.)

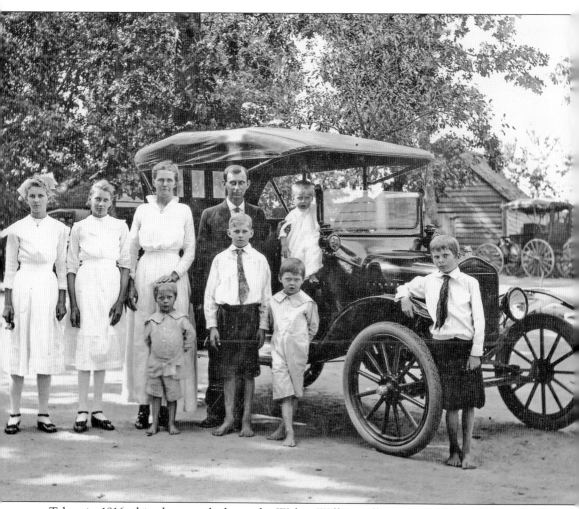

Taken in 1916, this photograph shows the Walter William Ellison family. Marie Ellison Ford said, "Beginning left to right is Nora Ellison. She married Rei Smith. Next is Lona Elllison. She never married. Grandmother Ellison is next. Her name was Nancy Elrod Ellison. We called her 'Nannie,' and she has her hand on Lester Ellison. Next is Granddaddy Ellison, Walter William Ellison, in the black suit. In front of him is John Raymond, called 'J.R.' The child in the car is Ralph Ellison. Standing in front of the child is Wesley Ellison. In front of the car is William Cleo Ellison, my father." (Courtesy of Marie Ellison Ford.)

This photograph was taken in front of the Cooley homeplace on Green Street. Pictured are first cousins of Vance Cooley including Nick King, Ann King, and Nell Martin.

Vance and Elizabeth Cooley married in 1953. This photograph was taken on their honeymoon to Hendersonville, North Carolina. (Courtesy of Vance Cooley.)

Just over an hour from Williamston, Hendersonville was a popular destination for honeymooners and tourists. (Courtesy of Vance Cooley.)

Mary Sue Brown attended the Anderson Girls' High School. She excelled on the basketball court and in the classroom, and was a published poet. She met a young fellow from Williamston named Harrison Tucker when he was a student at the University of Georgia. (Courtesy of Jane Tucker Addison.)

Harrison Tucker attended Bailey Military Academy in Greenwood before studying at the University of Georgia. He married Mary Sue Brown, and the couple raised four children on their farm on the outskirts of Williamston. (Courtesy of Jane Tucker Addison.)

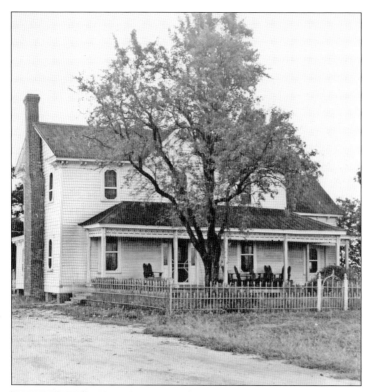

Pictured at left is the original homeplace of the Dave Tucker family. His wife, Ida Welborn, died when their younger son was only a baby. Dave raised five children: Mary Ann, D.J., Genevieve (Major), Harrison, and Inez (Roberts). (Both, courtesy of Jane Tucker Addison.)

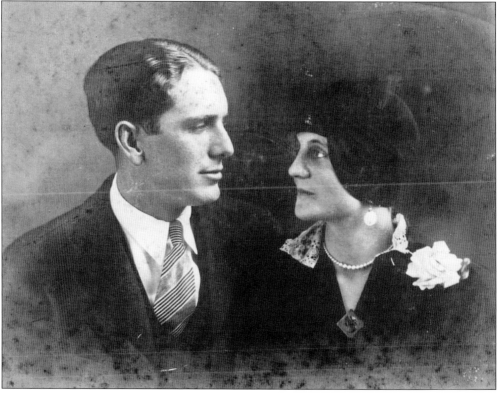

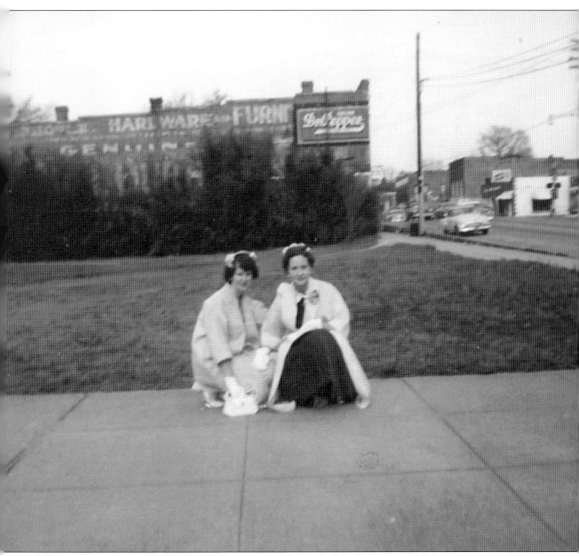

This picture was taken outside of what is now Town Hall looking toward Main Street with the Mineral Spring Park on the right. Many Williamston residents remember buying candy from Vincent Rhodes's shop, which sat in the row of brick buildings behind the women. (Courtesy of Jean Taylor.)

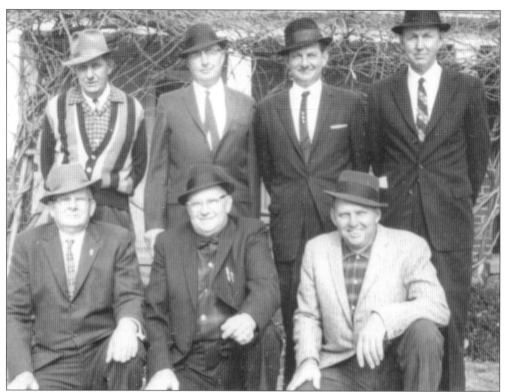

The Ellison brothers are pictured here. From left to right are (first row) William Cleo, Raymond, and Paul; (second row) Ralph, Lester, Broadus, and Wesley. (Courtesy of Marie Ellison Ford.)

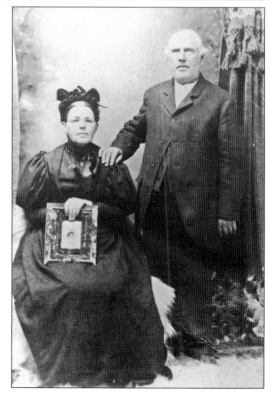

Mr. and Mrs. A.F. Welborn were active members of the Big Creek Baptist Church for many years. A.F. farmed and served on the board of the Williamston Female College. Their daughter Ida married Dave Tucker. Part of their farm was sold to the school district for the construction of the new Pelzer-Williamston High School. Other portions of the farm became the Shorebrook and Waterford subdivisions many decades later. (Courtesy of Jane Tucker Addison.)

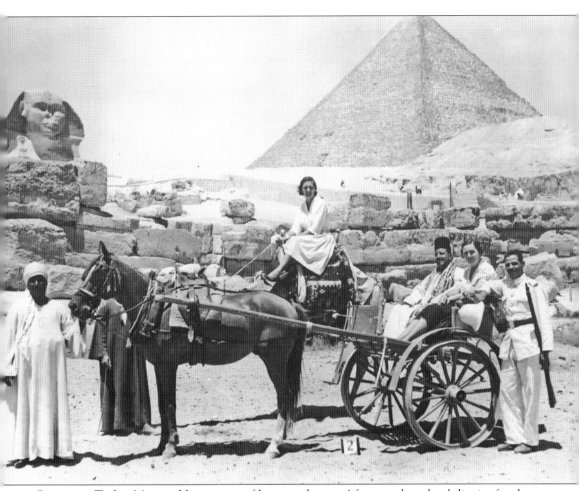

Genevieve Tucker Major sold a portion of her grandparents' farm to the school district for the construction of the new Pelzer-Williamston High School. Following the sale of the property, Mary Tucker McPhail accompanied her aunt Genevieve on a three-month trip around the world. The ladies visited Egypt during their extensive journey. (Courtesy of Jane Tucker Addison.)

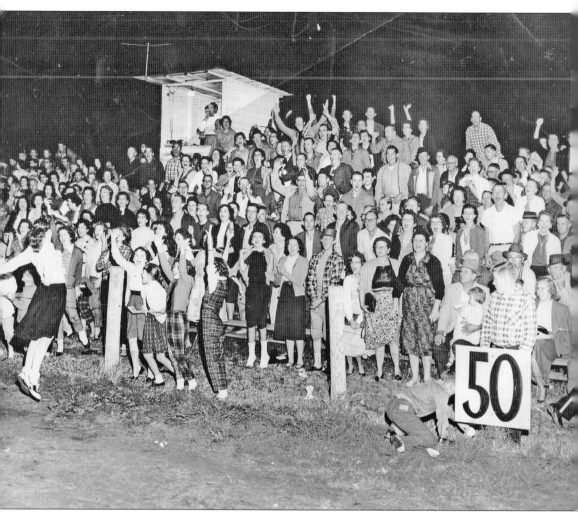

Taken in the fall of 1953, this photograph shows the enthusiasm and spirit of the new Pelzer-Williamston High School student body. While the school was under construction, a committee of nine women from Pelzer and Williamston held a contest in which people submitted ideas for a name for the new school. (Courtesy of Jane Harrison Harper.)

Inez Tucker and her two sisters, Mary Ann and Genevieve, studied education at Georgia's State Normal School. Inez married William Perry Roberts. They had one son, David William Harrison Roberts. (Courtesy of Jane Tucker Addison.)

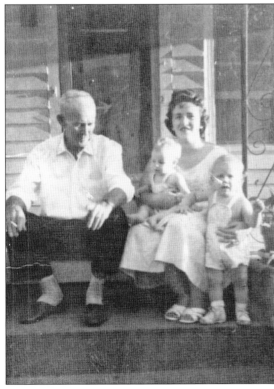

Here, Louise Morgan Ware is pictured with her grandfather J. Lex Morgan. Louise is holding her son Michael Taylor. Her brother Tommy is standing beside her. (Courtesy of Louise Morgan Ware.)

This photograph shows members of Louise Morgan Ware's family. From left to right are (first row) a stepdaughter of Harold Morgan, and Blanche Kinard Pollard's son James Pollard; (second row) Blanche Kinard Pollard, Elsie Kinard Morgan, Pet Kinard Cox, and Betty Black. (Courtesy of Louise Morgan Ware.)

Louise Morgan Ware is pictured here in 1942. She said, "Grandmother sewed all of my clothes. She could look at a dress and make her own pattern. She would cut patterns out of newspapers. Grandmother could make the best pecan pound cake. We were over there just about every Sunday. She could stretch any amount of food. Francis Wilson had a meat market. He and my grandmother would sit on the front porch to go over her grocery list." (Courtesy of Louise Morgan Ware.)

Louise Morgan Ware and her mother, Nora, are shown here at the wedding of Nola and Dewey Loggins. Louise was the flower girl in the wedding, and Nora was an attendant. (Courtesy of Louise Morgan Ware.)

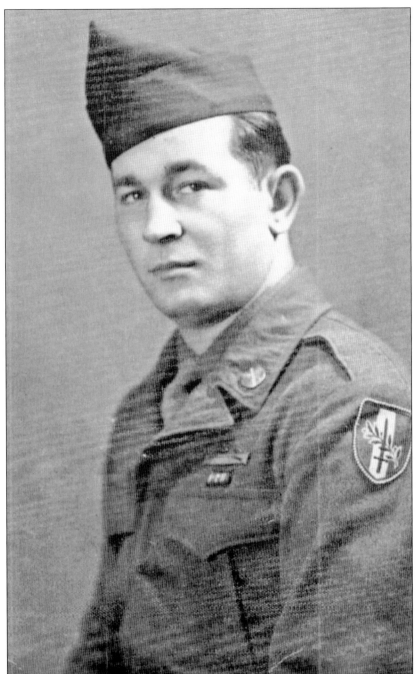

Louise's father, Ansel Morgan, served in the Army during World War II. His brothers Gerald and Glenn served in the Navy, and brothers David and Albert served in the Army, while Harold was in the Army Air Corps. Albert enlisted on the day President Roosevelt declared war, and was wounded in Normandy. With six sons serving in the war, Elsie Morgan received a letter from President Roosevelt allowing her to bring home one of her sons. She was unable to choose just one, so all six remained. President Roosevelt awarded her a sword with six stars. (Courtesy of Louise Morgan Ware.)

This photograph shows Louise Morgan Ware's mother and aunt. Louise said, "They were living in Tennessee then. Their mother died when they were six months old. They lived a hard life in the mountains. They were only able to go to school until the sixth grade, and while there, they had to share one slate. Snow blew through cracks in the school walls. When their father remarried, Nora went to live with a family member. She was just 10 years old. It was there she learned how to cook." (Courtesy of Louise Morgan Ware.)

Nola Loggins came to Williamston and lived with Judd and Bonnie Ray. She would ride a bus back and forth to Anderson to work in a mill. (Courtesy of Louise Morgan Ware.)

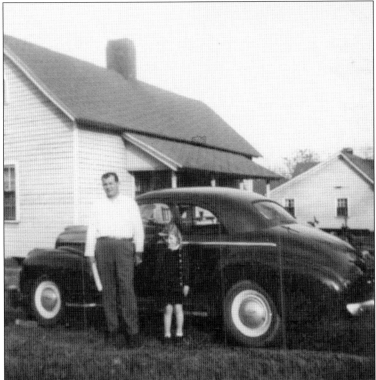

Louise Morgan Ware and her father are pictured on Second Street after World War II. Later, they moved to a house on Payne Drive. (Courtesy of Louise Morgan Ware.)

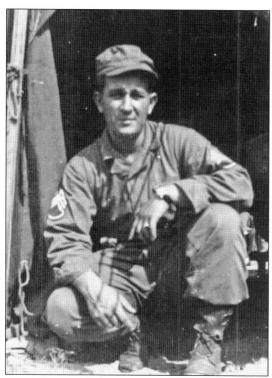

Ansel Morgan worked in the Williamston mill along with his father and brothers. He was offered a scholarship to Clemson University but turned it down to work in the mill. He was drafted into the Army in 1944. (Courtesy of Louise Morgan Ware.)

Pictured here is a group of boys who have spent their day working in the Williamston Mill in 1912. Conditions then would not have been vastly different from when Ansel Morgan worked there. (Courtesy of Library of Congress.)

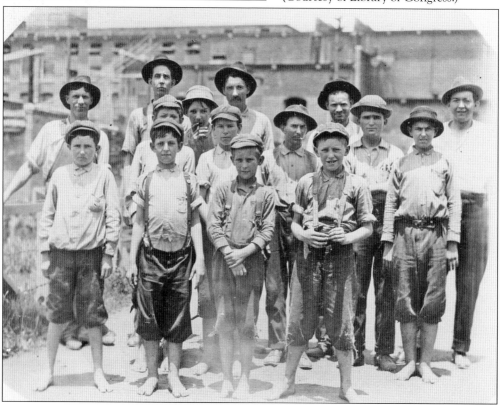

For a long time, cotton mills were an important driver of Williamston's economy. None of these mills were more influential than Williamston's mill, which employed hundreds of Williamston residents and guided the town to prosperity. Pictured here are mill executives, making decisions that moved the town forward. (Author's collection.)

Louise Morgan Ware is pictured with her mother, Nora, and her aunt, Nola, who was married to Dewey Loggings, then later to Furman Moody in her older years. Louise said, "Whenever Uncle Dewey bought anything, he would always buy it in threes so we could all match." (Courtesy of Louise Morgan Ware.)

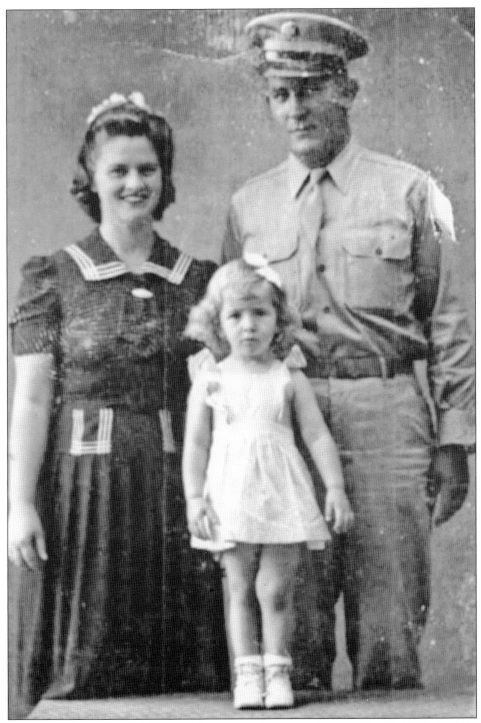

James Lexton and Elsie Arsela Kinard Morgan raised six sons who served in World War II. Albert, Ansel, and David served in Europe with the Army. Harold served stateside due to an injury. Glenn served in Europe and the Pacific with the Navy. Gerald also served in the Pacific with the Navy. (Courtesy of Louise Morgan Ware.)

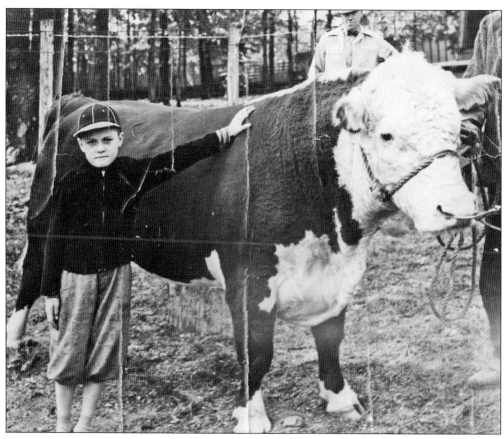

Harrison Tucker Jr. is pictured with his father's prize bull at the county fair around 1935. (Courtesy of Jane Tucker Addison.)

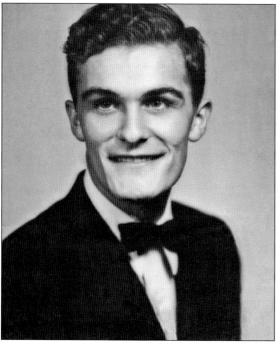

Harrison Tucker Jr. graduated from Williamston High School, Anderson Junior College, and Erskine College. This photograph was taken when he was at Anderson College. (Courtesy of Jane Tucker Addison.)

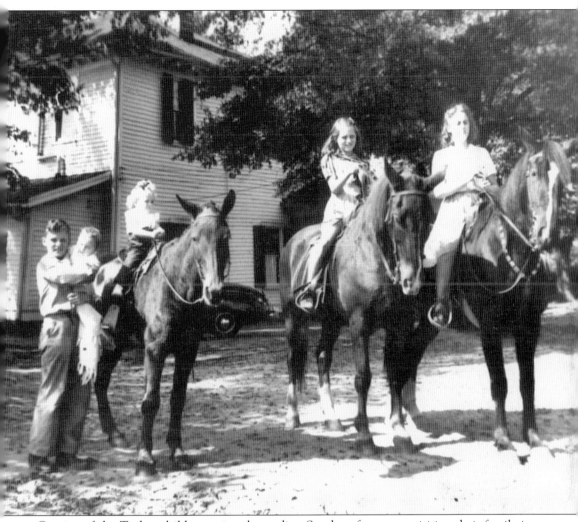

Cousins of the Tucker children enjoyed spending Sunday afternoons visiting their family in Williamston. They enjoyed riding horses, playing with all the animals, jumping on the bales of cotton or hay, and watching the small airplanes coming and going from the landing strip on the property. From left to right are Harrison Tucker holding his baby brother David, cousin Melinda Nachman (Wentworth), Mary Tucker (McPhail), and Harriette Tucker (Elrod). (Courtesy of Jane Tucker Addison.)

Towns like Williamston can be like a big family, with much of life spent in each other's company, sharing meals, and looking after each other. A homestead like this was a microcosm of this idea and would hold special memories for many Williamston residents.

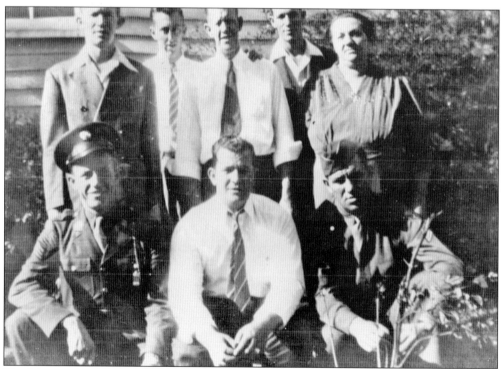

The Morgan family is pictured here in 1942. From left to right are (first row) William Albert Morgan, Joseph Ansel Morgan, and James Harold Morgan; (second row) Gerald Morgan, Glenn Morgan, father James Lexton "Lex" Morgan, David Morgan, and mother Elsie Arzella Kinard Morgan. Lex was born in 1893 and died in 1966. He is buried at Forest Lawn Memorial Cemetery in Anderson, along with his wife, Elsie, who was born in 1893 and died in 1960. (Courtesy of Louise Morgan Ware.)

Vance Cooley spent many afternoons with the Tuckers at the homeplace. Vance and Harrison "Buddy" Tucker Jr. were best friends. From left to right are Vance Cooley, Harrison Tucker Jr. holding David Tucker, and Tommy Poore. Behind the boys is Harrison Tucker Sr.'s office building, where he paid the people who worked for him. (Courtesy of Jane Tucker Addison.)

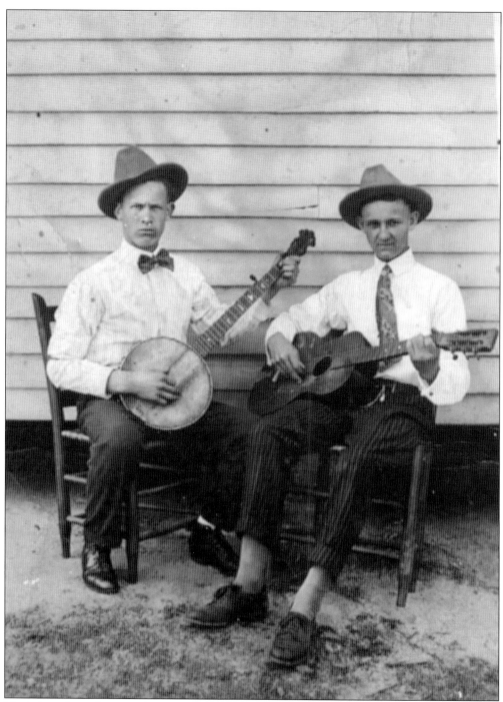

Music has always been a vibrant aspect of Williamston culture. These performers likely played a unique combination of country and traditional blues string music that was a signature style of the Piedmont regions of North and South Carolina. To this day, those influences are heard throughout the music of the town. (Courtesy of Louise Morgan Ware.)

Anna Rose Roberts Pinckney, the great-grandmother of Julie Cole, sits on the porch of the Pinckney house, which was located where Little Caesars Pizza is today. (Courtesy of Julie Cole.)

Julia Pinckney Gossett had two older sisters, Lavinia Gossett McDill and Suzanne Gossett Evans. Since Julia was the youngest, she was referred to as "baby sis." (Courtesy of Julie Cole.)

James Pleasant Gossett was born in Spartanburg on September 23, 1860. At the age of 10, he and his siblings became orphans when both parents died in the same year. The children lived with various friends and family members. James lived with his father's friend C.P. Brown for several years. He accepted a job in Williamston as a salesman in 1880. Working as a salesman for 15 years, James settled in Williamston and married Sallie Acker Brown, the daughter of Dr. and Mrs. Franklin Benjamin Brown. In 1895, James organized the Williamston Oil and Fertilizer Company and served as president. In 1889, he founded the Bank of Williamston and became its first president. By 1901, he had been appointed as the president and treasurer of Williamston Mills, which became the first of the Gossett Mill chain. Within nine years, he owned six of the 10 mills in Anderson County. James served as chairman of the board of trustees for Williamston Schools, director of Piedmont/Northern Railroads, and president of the American Manufacturers' Association in 1927. He was also one of the founders of the Cotton Textile Institute. By 1939, the Gossett Mill chain consisted of 12 mills in three states. James died on November 8, 1936. He is buried in Williamston Cemetery. Taken in November 1933, this photograph shows Sally and James Gossett celebrating their 50th wedding anniversary. (Courtesy of Julie Cole.)

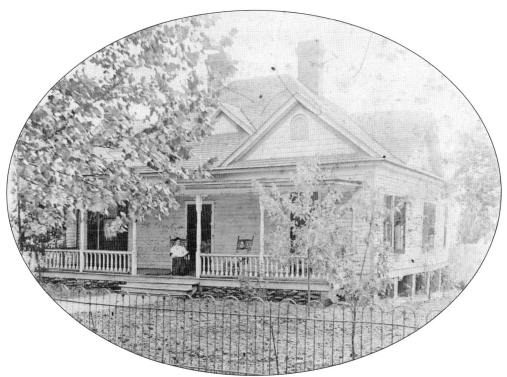

The Alfred G. Pinckney house on Main Street in Williamston is seen above in a photograph taken in 1900. The house stood where Little Caesars Pizza and Tolly Furniture are now located. Alfred served as postmaster in Williamston in the early 1900s. Alfred's wife, Annie Roberts Pinckney, is pictured here with her mother, Dorcas Elizabeth Gilreath Roberts. (Both, courtesy of Julie Cole.)

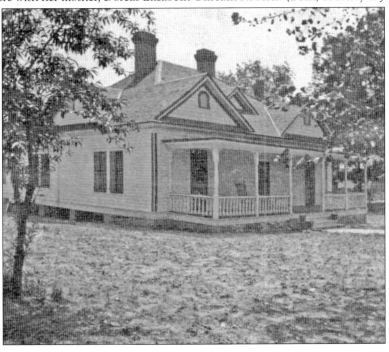

Theses photograph of Julia Gossett and housekeeper Lucia were taken on December 27, 1935, one week after a snowstorm. (Both, courtesy of Julie Cole.)

Taken in 1935, the photograph above shows the Gossett girls (from left to right) Lavinia, Frances, and Julia, along with their housekeeper, Lucia. (Both, courtesy of Julie Cole.)

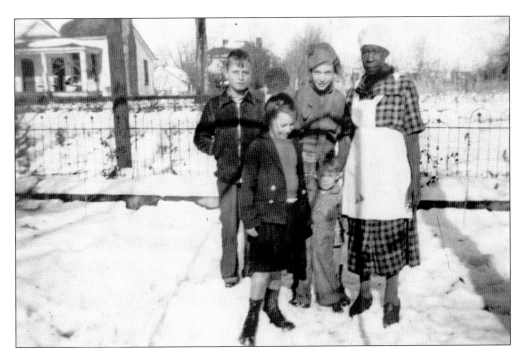

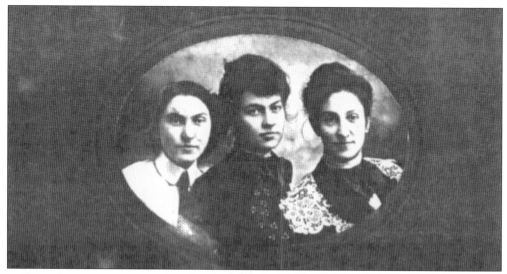

The Gossett sisters—(from left to right) Lavinia, Julia, and Frances—were the children of Julia Pinckney Gossett and Paul Gossett. (Courtesy of Julie Cole.)

The woman in this photograph is Annie Roberts Pinckney, the great-grandmother of Julie Cole. (Courtesy of Julie Cole.)

Julia deWolf Pinckney, seen here as an infant, is pictured with her mother, Annie Roberts Pinckney. Julia married Paul Gossett. They were the great-grandparents of Julie Cole. (Courtesy of Julie Cole.)

Annie Rose Roberts Pinckney was the daughter of Dorcas Elizabeth Gilreath Roberts and Lloyd B. Roberts. Dorcas was born on November 22, 1846, and died on March 7, 1932. Lloyd was born on December 4, 1841, and died on September 13, 1921. Both Dorcas and Lloyd are buried in the Williamston Cemetery. (Courtesy of Julie Cole.)

This unidentified couple portrays the grace and dignity many Williamston residents associate with the town's history. (Author's collection.)

Pictured here is Dorcas Gilreath Roberts (seated), the great-great-grandmother of Julie Cole. Standing beside her is Julia Pinckney Gossett, Julie's grandmother. (Courtesy of Julie Cole.)

Alfred G. Pinckney was born on March 22, 1866, and died on October 12, 1950. His wife, Annie Roberts Pinckney, was born on March 14, 1875, and died on February 29, 1938. Both are buried in the Williamston Cemetery. In this photograph, Alfred is standing, and the others are, from left to right, R.Q. Pinckney, Julia deWolf Pinckney, and Annie Roberts Pinckney. (Courtesy of Julie Cole.)

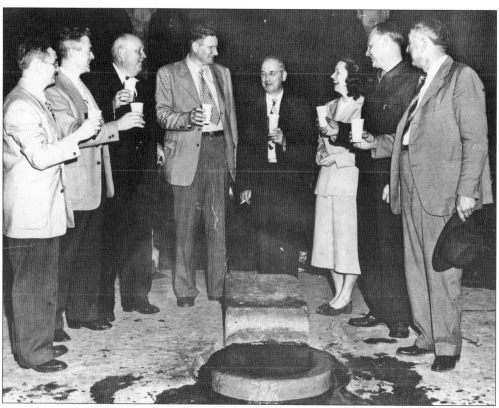

The event pictured here is unknown. Paul Gossett is at center, with Julia Gossett Mize on his left. The group appears to be drinking from the spring. (Courtesy of Julie Cole.)

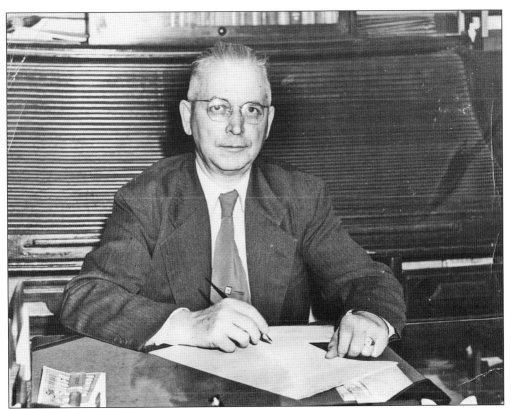

This photograph of Paul Gossett was taken when he planned to run for mayor of Williamston. He served as the town's mayor from 1949 to 1950 and from 1959 to 1960. (Courtesy of Julie Cole.)

Pictured here is a handwritten list of the members of the "Brothers of the Brush" who took part in the centennial celebration. (Courtesy of Jane Harper Lawess)

Married twice, John Arving Dacus had four children with each wife. He was born on December 25, 1849, and died on January 9, 1907. His first wife, Sarah Elizabeth Hogg Dacus, was born on May 3, 1854, and died on January 2, 1889. Their children were Ida Jane Dacus, Dr. Haude T. Dacus, Annie Dacus, and Mae Dacus. Dacus's second wife was Lula Jordan Dacus, born on November 25, 1871, and died on March 21, 1963. Their children were John Erving Dacus, twins Herbert Chesley Dacus and Harold Washington Dacus, and John Arving Dacus Jr. At left, dressed in Sunday clothes, John Dacus Sr. and Lula Jordan Dacus are pictured with their son John Dacus Jr. Below, Lula is pictured at age 87 in a *Greenville News* article on quilting. (Both, courtesy of Sarah Dacus.)

John Dacus Jr. married Nell Jameson Scruggs Dacus, who was born on June 6, 1914, and died on March 23, 2005. John and Nell had one child: John Arvin Dacus II, born on September 7, 1933. Still living at the age of 82 in 2016, John Dacus II is married to Sarah Allen Dacus. Their son John Arvin Dacus III died at the age of 45 on October 3, 2003. (Courtesy of Sarah Dacus.)

John Dacus Jr. and his wife, Nell, lived at 107 Dacus Street, which turns off Main Street. This photograph shows John Dacus Jr., Nell, and John Dacus III at Easter. John Dacus II and his wife, Sarah, lived around the corner. Sarah said, "John Sr. and Nell had a big yard—almost an acre. We would eat Easter dinner and hunt Easter eggs." (Courtesy of Sarah Dacus.)

Granny Dacus's first child died at the age of four from diphtheria. His name was John Erving Dacus Jr. He is pictured here at five months old in 1898. (Courtesy of Sarah Dacus.)

This photograph shows John Erving Dacus Jr. before his death in the early 1900s. Prior to the creation of an effective vaccine, diphtheria was a common illness and cause of death among children. Sarah Dacus said, "It was said he was a gifted child." (Courtesy of Sarah Dacus.)

Retired from the Navy, Harold Dacus lived with John Dacus Jr. and Nell on Dacus Street. Sarah Dacus said, "In a way, he helped raise my John." (Courtesy of Sarah Dacus.)

John Arvin Dacus II served in the Navy for four years. In October 1957, when he came out of the service, jobs were not plentiful in the area. He worked at Woody Simmons's gas station on Highway 8. Eventually, he accepted a job at the W.S. Lee Steam Station of Duke Power. He retired after 31 years as a control room operator. (Courtesy of Sarah Dacus.)

Five
CELEBRATIONS OF HERITAGE

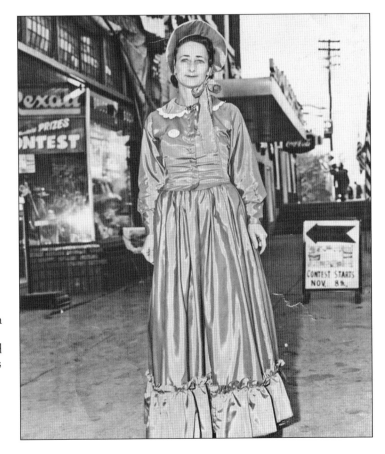

The centennial celebration in November 1952 meant a lot to town residents, most of whom participated in events. Locals dressed in period attire, as their ancestors would have been seen walking the streets of Williamston 100 years before. (Courtesy of Jane Harper Lawless.)

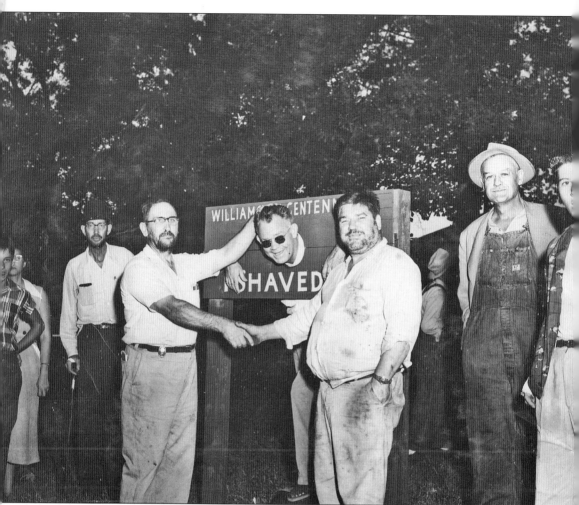

An estimated 100,000 people attended a weeklong centennial celebration in Williamston that began on November 9, 1952, and ended on November 15. In this photograph, Kenneth Henderson was accused of slandering the Brothers of the Brush. Henderson was tried before a jury including Mary Harper, Red Lollis, Ollie McKee, and Rev. Clyde Brooks. Because he was found clean shaven, he was placed in the pillory located on the grass outside of town hall. (Courtesy of Jane Harper Lawless.)

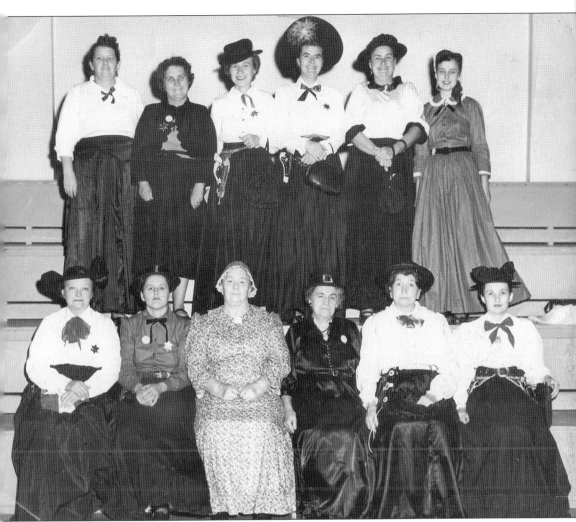

As the men grew beards to become members of the Brothers of the Brush, women wore outfits to resemble the attire of the mid-1800s. Women who wore the long skirts and period clothing were Sisters of the Swish. The 70 women wore long dresses, no makeup, and no nail polish. Mary Harper reported in the *Anderson Independent*: "Members of the sisterhood must not smoke, dip, or chew in public. Pipe smoking will be allowed." Mrs. John D. Attaway Sr. was chairman of the Sisters of the Swish, Lilly Russell served as judge, Mary Harper was the solicitor, Jeanell Poore served as sheriff, Mrs. Charlie Ragsdale was the sheriff's assistant, Elizabeth Galloway served as coroner, and Gladys Wood was both secretary and treasurer, with Dot Thomason as her assistant. Sisters of the Swish pictured here are, from left to right, (first row) Jeanell Poore, two unidentified, Inez Wilson (postmistress), Mrs. Curt Walker, and unidentified; (second row) unidentified, Mrs. Rice, Clare McCowen, Mrs. Kelly, Roxie Mackey, and Mrs. Tilman Galloway. (Courtesy of Jane Harper Lawless.)

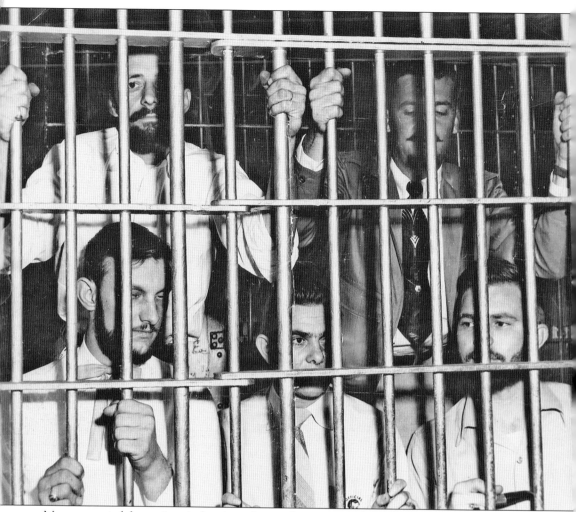

Men were tried for various infractions during the centennial celebration. Some were accused of pretending to be a member of the Brothers of the Brush without signing the brotherhood's pledge. Williams Holland was accused of making slanderous remarks about the brotherhood. After spending time in the pillory at town hall, accused men were placed in the jail for a small amount of time. (Courtesy of Jane Harper Lawless.)

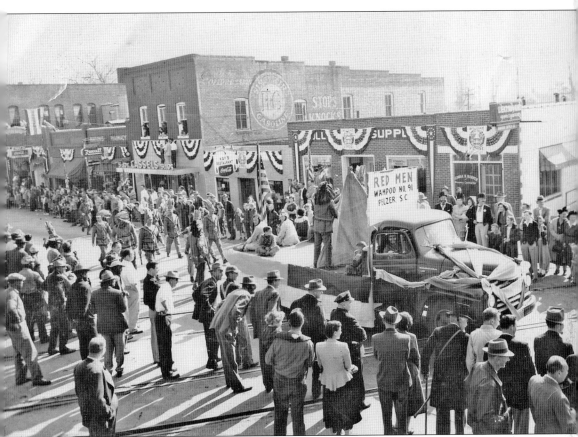
Daily parades were part of the weeklong centennial celebration. Parade participants included beauty queens, bands, majorettes, floats, and pre–World War I automobiles. (Courtesy of Jane Harper Lawless.)

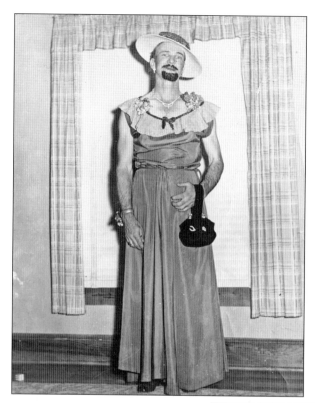

The Brush Revue of '52 starred bearded men from Williamston. The *Anderson Independent* described it as "a girlie show complete with chorus line and beauty queen." The revue was an all-male presentation sponsored by the Anderson Police Association and performed at the municipal auditorium in Williamston. (Courtesy of Jane Harper Lawless.)

The Brush Revue of '52 featured a variety of musical and novelty acts. Adults could see the revue for 50¢, and children could attend for 25¢. Proceeds were divided between the Anderson Police Association and the Williamston Centennial Fund. (Courtesy of Jane Harper Lawless.)

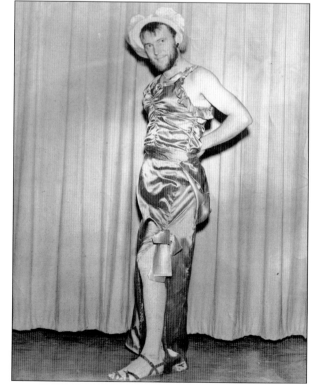

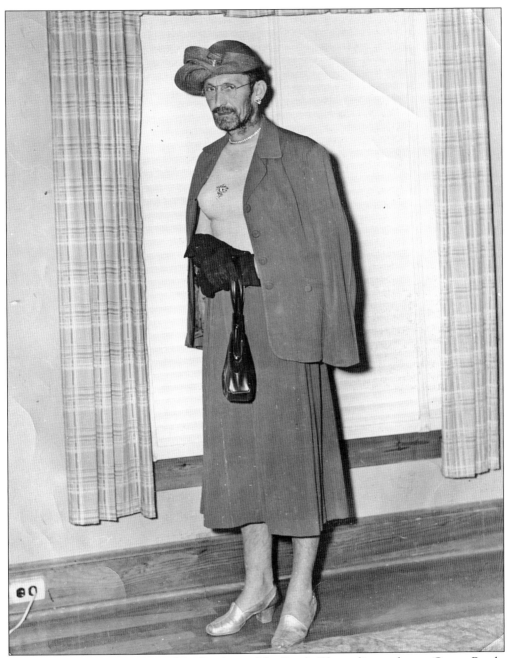

The revue cast were members of the Brothers of the Brush. The audience chose a Queen Brush. Along with the revue, Sisters of the Swish prepared a box supper. These packaged meals were auctioned off, and the buyer and packer ate together. (Courtesy of Jane Harper Lawless.)

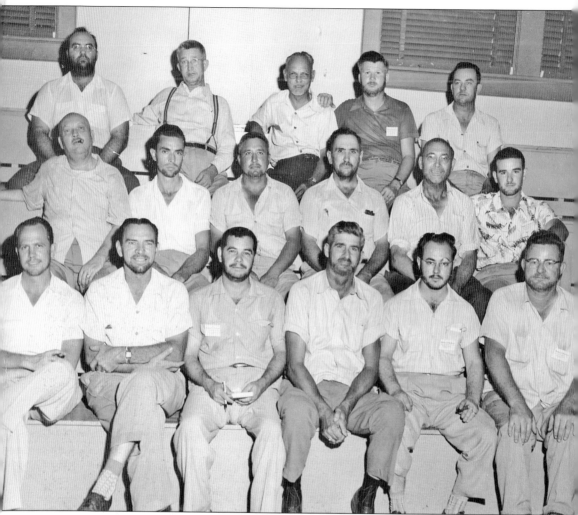

These Brothers of the Brush members are, from left to right, (first row) Chairman Tillman Galloway, Cochairman J.B. Ashley, Secretary and Treasurer George Poore, Sherriff Pete Harper, Deputy Grady Staton, and Chief Deputy Floyd Knight; (second row) Deputy Roy Norris, Deputy Ed Vandiver, Deputy Ed Poore, Deputy Chris Cothran, Deputy John Newton, and Deputy Guy Bagwell; (third row) Deputy Jack Turner, Deputy Adj. Davenport, Magistrate Fred Tolly, Deputy Ray Pollard, and Deputy Cully Bagwell. (Courtesy of Jane Harper Lawless.)

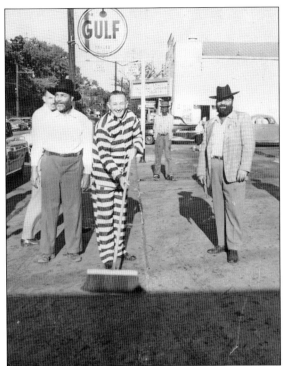

During the centennial celebration, Brothers of the Brush played pranks on each other. If found in contempt of any rules, accused men had to wear striped clothing and pay for their crime. (Both, courtesy of Jane Harper Lawless.)

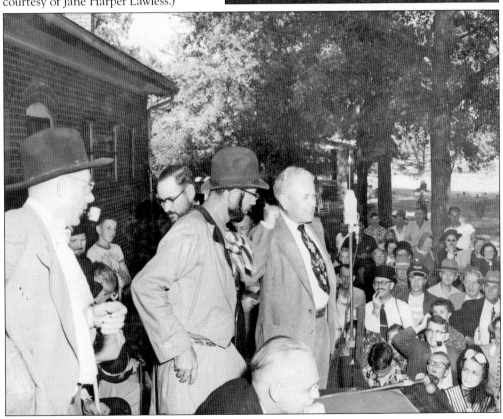

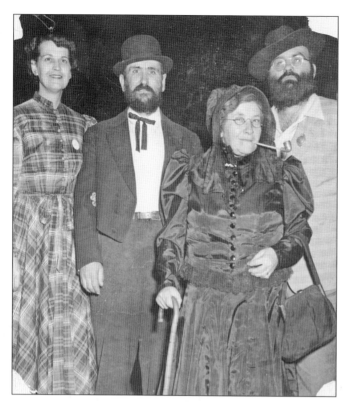

This photograph of the When Pa was courtin' Ma event ran in the *Anderson Independent* in 1952. Williamston residents enjoyed dressing in clothing from 1852. (Both, courtesy of Jane Harper Lawless.)

When Pa was courtin' Ma was fun for the whole community. Many families had these period clothes handed down to them from parents and grandparents, uniting Williamston behind its shared history. (Courtesy of Jane Harper Lawless.)

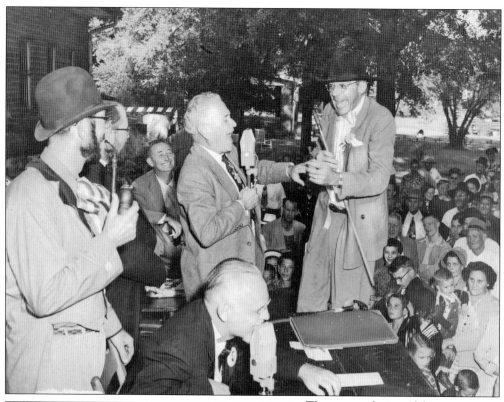

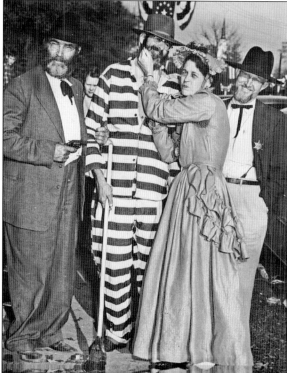

The camaraderie and fun was apparent during the centennial celebration. Pete and Mary Harper enjoyed the festivities. Pete was a prisoner during the week. (Both, courtesy of Jane Harper Lawless.)

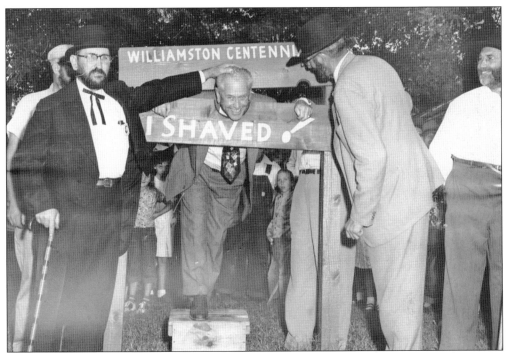

Truman Bennett, a retired Williamston businessman at the time, went on trial for violating regulations set by the Brothers of the Brush. Truman did not sign the pledge to grow a beard for the event. (Both, courtesy of Jane Harper Lawless.)

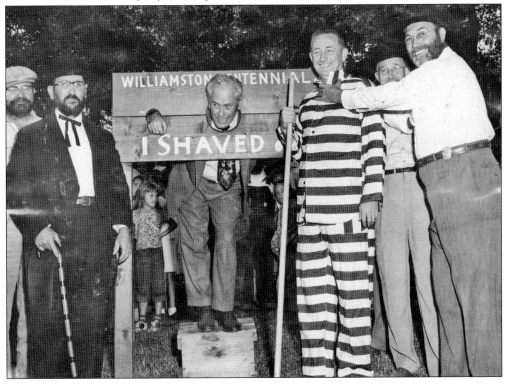

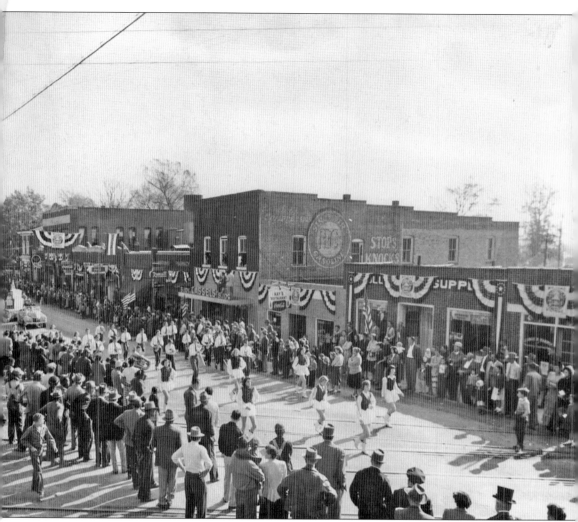

During the weeklong celebration, hundreds of schoolchildren in Williamston took part in the Armistice Day parade on November 11, 1952. At the time, schools were still segregated. Students from all schools participated in the parade. (Courtesy of Jane Harper Lawless.)

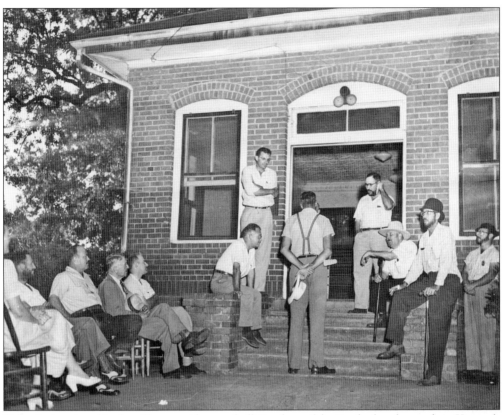

Before being placed in the pillory outside town hall, Brothers of the Brush played a prank on Kenneth Henderson (seated on the steps) when they accused him of slandering the brotherhood by not growing a beard. "Sheriff" Pete Harper, with his back to the camera, was questioned by "Prosecutor" Chris Cothran, standing at the top of the steps. (Both, courtesy of Jane Harper Lawless.)

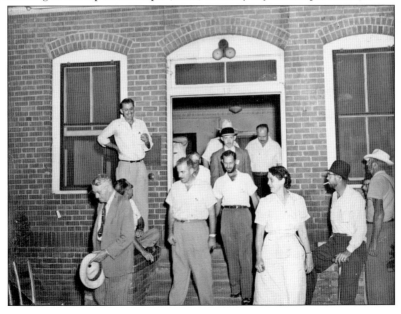

117

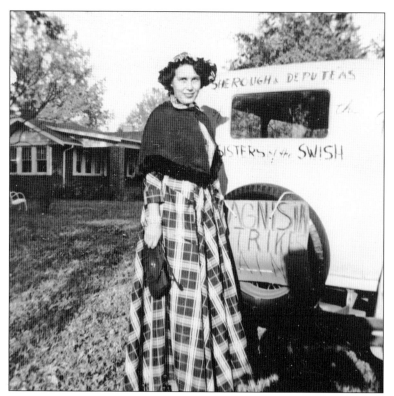

These photographs show members of the Sisters of the Swish. The group had a "sheriff" with assistants who wore black skirts, white shirts, red ties, and sailor hats on days they planned to make arrests. When arrested, offenders spent 10 minutes in the pillory on the town hall lawn. (Both, courtesy of Jane Harper Lawless.)

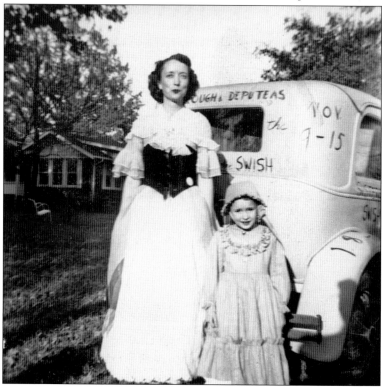

The entire town participated in the centennial festivities. Louise Morgan Ware and her father are seen prior to attending a centennial event. He had just finished his shift at the mill. (Courtesy of Louise Morgan Ware.)

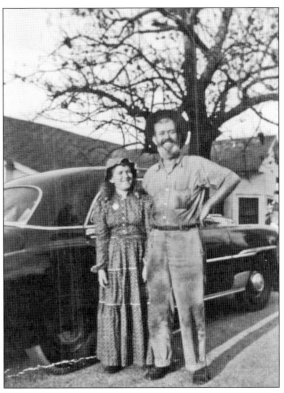

Jane Harper Lawless is pictured with her father, Pete, who served as the "sheriff" for the Brothers of the Brush. He made his first "arrest" when he apprehended Rev. Paul Mabry of the First Baptist Church for shaving his mustache. (Courtesy of Jane Harper Lawless.)

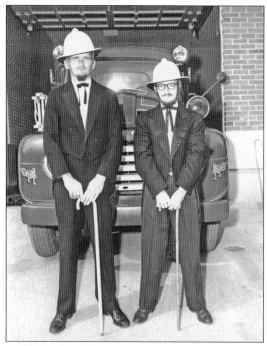

The Williamston Fire Department participated in the centennial celebrations. Fire Chief Mike Simpson and Assistant Chief Tommy Walker are pictured here in 1952. Jim Simpson said, "Memories of my dad's devotion to the fire department go back to my early childhood. Although I was only 15 when my dad passed away, I distinctly remember the many nights I heard him leave in response to a fire alarm. I can still see the large rubber boots with the attached pants and suspenders that sat in the corner of my parents' bedroom ready to go at a moment's notice. I can still smell the smoke on his clothes when he gave me a hug the next morning." (Courtesy of Steve Ellison.)

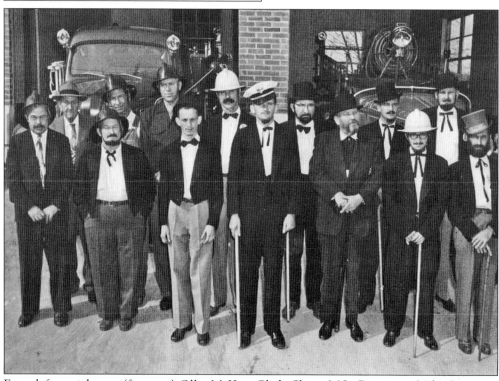

From left to right are (first row) Ollie McKee, Clyde Shaw, M.L. Patterson, Mike Simpson, "Chubby" Norris, Tommy Walker, and Rudolph Varnadore; (second row) DeWitt Stone, Herman Cannon, Morgan, Roy Burns, Tom Walker, Derwood Boyce, and Cleo Ellison. (Courtesy of Steve Ellison.)

Martha Phillips was named Miss Williamston. She won the title by selling the most tickets to the historical centennial pageant, Our Happy Land, written for the centennial celebration. Martha was the daughter of Mr. and Mrs. J. Arthur Phillips. At time of her crowning, she was 17 years old and a student at Anderson College. She graduated from Williamston High School in 1952. She studied home economics at Anderson College and planned to transfer to Furman University. (Courtesy of Jane Harper Lawless.)

After being named Miss Williamston, Martha Phillips joined in the festivities with her friends, including Nancy Bryant, who received second place; Algera Breazeale, third place; and Patricia Elrod, fourth place. (Courtesy of Jane Harper Lawless.)

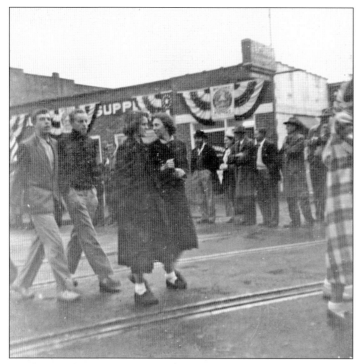

Betty Looper Addison said the week of the centennial was great. "I was just a teenager," she said. "I was around 17. We had a parade every day. At the end of that week, they had us to walk across the stage. It was a really exciting time." (Both, courtesy of Jane Harper Lawless.)

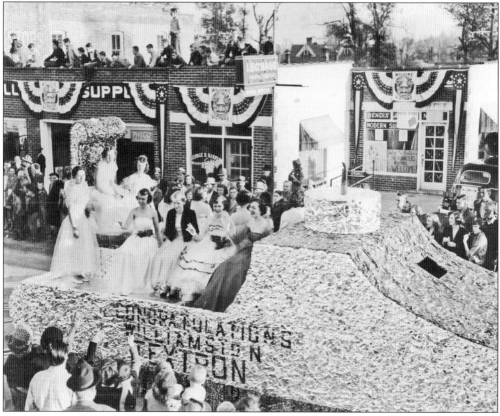

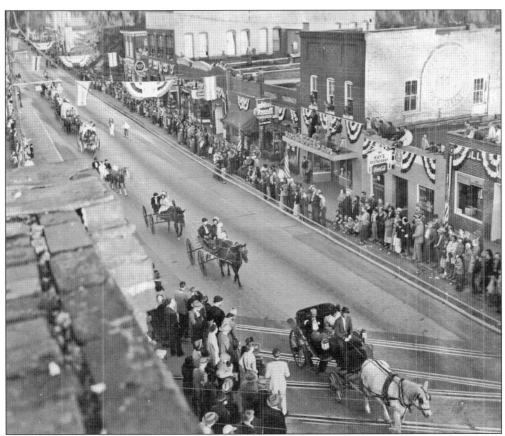

Noted as a colorful event with floats, bands, beauties, and gala decorations, the parade on Armistice Day included historical and significant floats from neighboring towns. High school bands, Boy Scouts, and Miss Williamston and her court participated in the parade. (Both, courtesy of Jane Harper Lawless.)

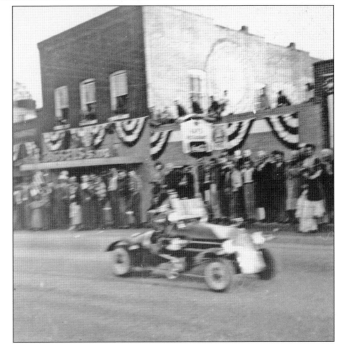

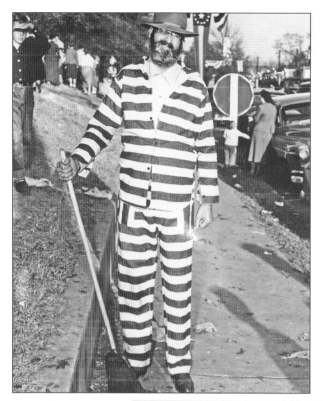

Pete Harper, father of Jane Harper Lawless, dressed as a prisoner during the centennial. Married to Mary Harper, a correspondent for the local newspaper, Pete Harper found himself the feature of various news articles. During the centennial celebrations, the *Anderson Independent* ran an article about a visit Pete made to the Williamston Hospital. The hospital staff realized a tooth was the problem and sent Pete to his dentist, who extracted an errant tooth from the roof of his mouth. The Brothers of the Brush apparently claimed fame because Pete was one in 2,000 people to have this medical anomaly. (Both, courtesy of Jane Harper Lawless.)

Each year, the town of Williamston decorates Mineral Spring Park with Christmas decorations. Families make it a tradition to visit the park to see the lights and displays. (Both, courtesy of Jane Tucker Addison.)

As a small child, Jack Ellenburg (left) made instruments out of anything he could find on the farm where his family lived as sharecroppers. Later, he opened the Pickin Parlor on the outskirts of town where people came to both play and listen to bluegrass music. Ellenburg's spirit of compassion radiates throughout town. During the summer, he plays with other musicians at the weekly farmers' market in the Mineral Spring Park. He describes those weekly sessions as "a heartwarming experience in bluegrass with a down home style." (Courtesy of Sonya Crandall.)

The vision of West Allen Williams to create a town where families could prosper included establishing a community of commerce. The town's commerce group, the Palmetto Business Association, and the town's Main Street development program, Envision Williamston, promote and support business growth and success through ribbon cuttings, visual enhancements, and community involvement. (Courtesy of Sonya Crandall.)

The Cohen brothers revitalized the former Gossett Mill in 2010 when they brought their wholesale fabric business to Williamston. The Cohen family has been in the textile industry for four generations, starting in the early 1900s when the elder Mr. Cohen came from Russia and peddled fabrics to companies out of New York. Today, Phoenix of Anderson is a fully diversified textile company working with consumers and over 1,000 wholesale customers. They also export fabrics to more than 30 countries around the world. For three days each month, Phoenix of Anderson opens its doors to the general public. (Courtesy of Eric Cohen.)

The current administration of Williamston sees a town of honor, heritage, and hope. From left to right are town council member Rockey Burgess, Mayor Mack Durham, Envision Williamston director Sonya Crandall, town council member Otis Scott, town council member Tony Hagood, and town council member David Harvell in front of a new directional sign implemented in 2016. Envision Williamston is committed to the health and wellness of the Williamston community, using a holistic approach to promoting economic revitalization, social engagement, local visibility, and community partnerships. (Courtesy of Sonya Crandall.)

Discover Thousands of Local History Books Featuring Millions of Vintage Images

Arcadia Publishing, the leading local history publisher in the United States, is committed to making history accessible and meaningful through publishing books that celebrate and preserve the heritage of America's people and places.

Find more books like this at
www.arcadiapublishing.com

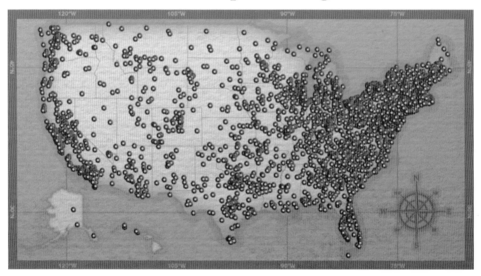

Search for your hometown history, your old stomping grounds, and even your favorite sports team.

Consistent with our mission to preserve history on a local level, this book was printed in South Carolina on American-made paper and manufactured entirely in the United States. Products carrying the accredited Forest Stewardship Council (FSC) label are printed on 100 percent FSC-certified paper.